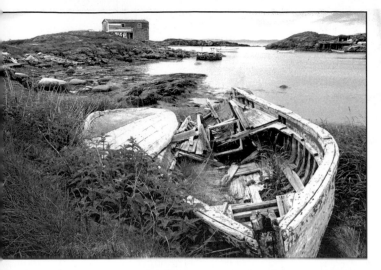

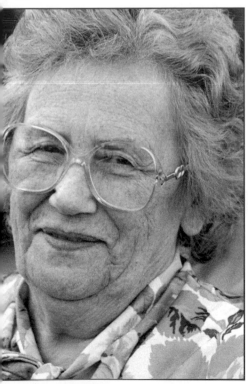

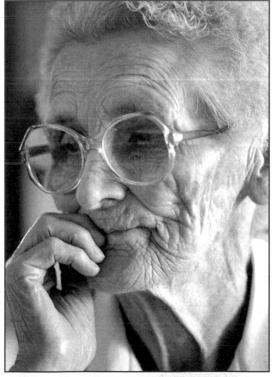

Island Maid

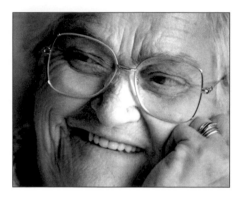
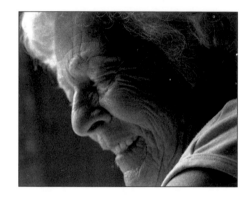
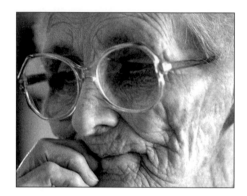

SHEILAGH O'LEARY

PHOTOGRAPHY

Island Maid

VOICES OF OUTPORT WOMEN

RHONDA PELLEY

TEXT

BREAKWATER

Library and Archives Canada Cataloguing in Publication

Pelley, Rhonda, 1968-
Island Maid: voices of outport women /
text by Rhonda Pelley;
photography by Sheilagh O'Leary;
foreword by Roberta Buchanan.

Includes bibliographical references.
ISBN 978-1-55081-325-8

1. Women--Newfoundland and Labrador--Social conditions.
2. Older women--Newfoundland and Labrador--Interviews.
3. Newfoundland and Labrador--Social conditions.
I. O'Leary, Sheilagh II. Title.

HQ1459.N48P44 2010 305.26'20922718 C2010-902108-8

We acknowledge the financial support of
The Canada Council for the Arts, the Government
of Canada through the Canada Book Fund
and the Government of Newfoundland and Labrador
through the department of Tourism, Culture
and Recreation for our publishing activities.

BREAKWATER BOOKS
www.breakwaterbooks.com

To my father

SEAN O'LEARY

a gregarious, history-obsessed man
who set the seeds for my deep-rooted fascination
with Newfoundland people and their stories.

— SHEILAGH O'LEARY

For my mother

SANDRA PELLEY

— RHONDA PELLEY

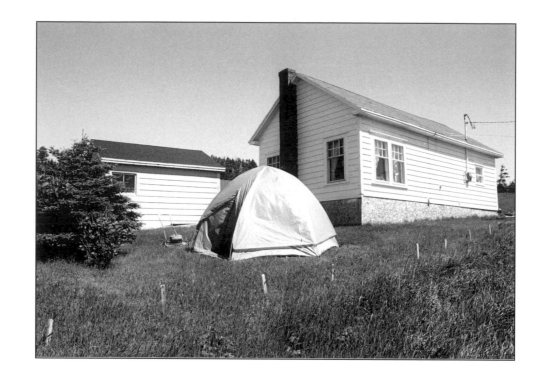

Foreword ... 9

Introduction ... 13

Jamestown ... 18

Olive Blundon ... 21

Change Islands ... 28

Beulah Oake ... 33
Bessie Hurley ... 43
Flora Whitt ... 51

The Codroy Valley ... 56

Minnie White ... 61

Bay St. George ... 63

Sarah Benoit ... 65

Hawkes Bay, The Great Northern Peninsula ... 72

Viola Payne ... 75

Pasadena ... 82

Phyllis O'Leary ... 85

The South Coast 92

Beatrice Sibley ... 97
Annie Dollimount ... 101
Vivian Cluett ... 109

Afterword ... 117

Acknowledgements ... 119

Foreword

BY ROBERTA BUCHANAN

PROFESSOR EMERITA, MEMORIAL UNIVERSITY OF NEWFOUNDLAND

One day two young women came to my office in the university with an exciting idea. They wanted to rent a van and drive around the island interviewing and photographing older outport women. Their intention was to record the faces and experiences of their women elders in Newfoundland. Would I support their application to the Newfoundland and Labrador Arts Council for funding? I would, and did.

Sheilagh and Rhonda had been my students in Women's Studies 2000, an interdisciplinary introductory course I was teaching at the time with the charismatic Anne-Louise Brookes. These were still the heady pioneering days of Women's Studies. We were interrogating everything and encouraging our students to do likewise: the relationship between gender and power, socialisation, economic disparity, unpaid domestic work, violence against women, the sexual abuse of children, sexism encoded in language, *her*story as opposed to *his*tory. There was even a whiff of danger to the enterprise. One semester a young woman came to the first class escorted by her boyfriend. At the end of the class, the boyfriend came up to me and said in a threatening manner, "You had

better be careful." He did not register for the course, although his girlfriend did, or perhaps was allowed to, maybe as a spy? The thought that we might be a thorn in the side of the Patriarchy, regarded as dangerous and subversive radicals, filled us with glee. It was not so funny when, in December 1989, a young man, Marc Lepine, entered a classroom at the École Polytechnique in Montreal and gunned down fourteen women engineering students. If anyone was going to blow away a bunch of feminists at Memorial, Women's Studies 2000 would be a good place to start.

One of the keywords of the feminist enterprise was *foremothers*. Who were our foremothers – in the arts, the sciences, in politics, in the fight for equality and social justice, in everyday life? And not just women "from away," as we say in Newfoundland. All our students in Women's Studies 2000 had to write their comments on course material in their journals, which had to be handed in every second week. Their own personal experiences, and those of their mothers and grandmothers, might be very relevant to the issues being discussed. We encouraged them to think about Newfoundland "herstory" and their own "foremothers," the women often "hidden from history." "Women's work" was often dismissed as "trivial" and not worthy of consideration. Newfoundland women not only bore and raised children – and one woman might have had as many as twenty-one children, as well as pregnancies ending in miscarriages, in the days before the legalisation of contraception in Canada (1969). They also fed and clothed their families, sometimes even carding and spinning their own wool. They planted gardens of vegetables, kept chickens, goats and cattle, and in addition, worked on the fish flakes "making" the salt cod, formerly the mainstay of the Newfoundland economy. One of my students described seeing his grandmother walking out of the woods with a quarter of moose on her shoulders, which she had just shot and butchered – a far cry from the urban milieu in which I grew up. As one Newfoundland fisherman said, women were "more than fifty percent" in the work they did: "She was more than fifty per cent … She was the driving force" (quoted in Murray, *More Than Fifty Percent*). At the time, research on Newfoundland outport "herstory" was in its infancy. Hilda Murray's pioneering work, *More Than Fifty Percent: Woman's Life in a Newfoundland Outport, 1900-1950* (Breakwater, 1978), focussed on her own community of Elliston, Bonavista Bay. If you wanted to know something about the lives of outport Newfoundland and Labrador women, from their own perspectives, you had to turn to the few autobiographies that had been published, mainly by Labrador women: Lydia Campbell's *Sketches of Labrador Life*, her daughter Margaret Baikie's *Labrador Memories: Reflections at Mulligan*, Elizabeth Goudie's *Woman of Labrador*, and Millicent Blake Loder's *Daughter of Labrador*. Loder was the first Labrador-born nurse.

So when Sheilagh and Rhonda walked into my office with the idea for the Island Maid project, I was delighted. They were both well-known activists on the local scene, co-founders of the Peace-a-Chord Festival, a vibrant event organized by and for the youth of St John's. Sheilagh was an accomplished photographer, who had studied feminist theory and photography at Concordia University. Rhonda participated in a women's "Writing Our Lives" course that I taught for Memorial University Extension. Women have interesting stories to tell, and it was time that they told them! Rhonda adapted and developed the writing exercises I used in the course into an exhaustive four-page questionnaire for interviewing the outport women. Would she ever get through her four pages of probing questions, I wondered, without getting thrown out by her exasperated interviewees?

Rhonda and Sheilagh got their grant, and set off in a van loaded with photographic and camping equipment on their perambulation around the island. In due course, in 1993, the exhibition "Island Maid," with photographs by Sheilagh and text compiled by Rhonda, was shown at the Resource Centre for the Arts Gallery, LSPU Hall. It was an immediate success, and was purchased by the provincial government for their collection. But the one page of text accorded each woman ("maid" in Newfoundland parlance) could only scratch the surface of Rhonda's interviews. The logical next step was to produce this book, which would tell the story of the process in greater depth, using the journals Rhonda kept on the road, giving the interviews in greater detail, and adding more photographs.

Since their project on outport women, Sheilagh and Rhonda have gone on to further artistic accomplishments. This is Sheilagh's second book of Newfoundland photographs: *Human Natured: Newfoundland Nudes* (Boulder Publications, 2007) resulted from an exhibition of an evocative series of nudes posed among Newfoundland rocks. As a photographer, Sheilagh is particularly interested in portraits: her exhibition "Twinning Lines" paired portraits of Irish and Newfoundland subjects of common ancestry, and was shown in Ireland and Newfoundland; "More Than Meets the Eye" was a study of individuals with Down's syndrome. Sheilagh is also a film-maker. Her half-hour documentary, *Sisters of Mercy*, a history of the Mercy Sisters' hundred years of service on the west coast of Newfoundland, won the Linda Joy Busby Media Arts Award in 1993. Most recently Sheilagh was elected to the St John's City Council, polling the most votes of any councillor in the election.

When I last talked to Rhonda, when we were first discussing the Island Maid project, she was just off to Prague, then a mecca for young artists after the fall of the communist era and the arts-driven "Velvet Revolution." Since then she has become a respected visual artist. Her work has been shown

in San Francisco and Lausanne, Switzerland, as well as in Newfoundland. Rhonda is also involved in the theatre, as set designer and writer. Her latest exhibition, "Penetralia," at the Leyton Gallery of Fine Art, contained haunting photographs, some suggesting women's oppression. One of them was titled *Aphonia*, voicelessness. In *Island Maid*, we hear at last the voices of outport women, in all their variety and strength.

The pairing of portrait and word is effective in conveying the "strong, self-aware women" that Rhonda and Sheilagh were in search of. Their idea was to go deeper than the cliché-ridden image of the cookie-making grandmother. "Snaps won't work," Sheilagh told fellow-photographer Manfred Buchheit (*Newfoundland Signal*, August 1990). She refused to use a flash, and photographed with the available light, in order to get a more natural look. She was trying to convey the "self-awareness and presence" of the individual, "so you can feel the person speaking," she told Buchheit. In the excerpts from Rhonda's taped interviews, we can hear each woman's individual voice and how she defines and narrates her own experience of life.

This is a delightful book, in part a story of two young women "on the road." How they enjoy themselves! They wash in a brook, or run into the sea; they make tea and refried beans over their campfire; they climb the second highest mountain in Newfoundland. At the top, Sheilagh exuberantly waves her shirt. I found myself longing to follow in their footsteps, to see the green meadows rolling down to the pebbled beach, take the ferry to Change Islands and stay at Beulah Oake's bed and breakfast, the Seven Oakes Inn and Cottages, or view Pasadena, "soft as a pillow."

The women interviewed radiate a quiet joy of lives well lived, despite the hardships they endured, and pride in their communities. "People were very caring … You wouldn't find a more loving people," Olive Blunden says. Yet their lives were ones of hardship and unremitting toil. They raised families in houses without running water, without central heating or electricity, with no nurse or doctor for miles, in crushing poverty – paid ten cents, or even three cents, a quintal for "making" the fish. We forget how easy our lives are now (at least in the "developed" countries; not so easy in Africa or Asia). Now, "It's just … plug in this and plug in that," as Flora Whitt says. "The younger ones can't believe it, all the work we did," Annie Dollimount comments.

This is a book to treasure, to give to one's elders, in tribute to their hard lives, and to give to the younger ones, to remind them of what their "foremothers" endured.

Introduction

There is a woman who once lived in a blue house on the end of a street in St. John's. She had three handsome sons who were musicians. Every day, after high school let out, they brought a giant stereo speaker out to their front steps, put on some rock and roll and sat waiting for the girls in their uniforms from the Catholic school up the road to walk by. Soon, they began collecting friends from schools of other denominations as well. This woman, their mother, opened her doors, and let us in. We spent all our time there.

The living room had a woodstove used so much during the winter that its outside would glow red from the heat. On the wall in the kitchen hung a framed print of *The Harvesters* by Pieter Bruegel. On the second floor, in one of the boys' bedrooms, was a large theatre flat of a St. John's street scene.

The flat was created by the theatre group Sheila's Brush for their outdoor protest show, *Pavement Pageant Profiles*. The play was performed on Brazil Square in St. John's. The area was being razed to put up the new Radisson Hotel and many people were losing their homes to this development.

It was the mid 1980s, the era of Brian Mulroney, Margaret Thatcher and Ronald Reagan. Nelson Mandela was still in solitary confinement in South Africa. Augusto Pinochet was still dictator of Chile, and Imelda Marcos was buying too many shoes. There were also signs that there may be problems with our fishery, an echo of things to come.

That blue house on the end of the street became the meeting place for young people, members of the arts community, and social action groups. It is where the Peace-a-Chord Festival began and it is where Sheilagh and I met.

The Peace-a-Chord was a two-day music and social action festival created to empower young people. The local office of Oxfam Canada gave us their first floor and when we weren't spending all night in those offices drinking too much coffee and plotting ways to change the world, we were out dancing to punk and folk rock bands.

During the five or so years that we organized this festival, we brought in musical acts and political speakers from across Canada and around the world, including Amauta from Chile and the South African musical group Amandala. They performed their country's "gum boot dance," a dance originally performed by miners as a way to keep warm in the cold.

By 1990, we were still organizing the festival but things had changed. Nelson Mandela had been released, the "Velvet Revolution" in former Czechoslovakia had begun, the Berlin Wall was demolished and the Cold War was over. But here at home, another cultural crisis was emerging. It was the beginning of the cod moratorium. A way of life that had sustained Newfoundlanders for four centuries was devastated. Massive protests were held on the waterfront in St. John's and at the Confederation building. The local TV and radio stations were alive with angry, desperate voices of dissent.

Sheilagh and I were attending a women's studies class at Memorial University. It was taught by Professors Roberta Buchanan and Anne-Louise Brookes. Discussions centered on gender and power as well as on the undocumented contributions women have made throughout history.

It was also at that time that I attended a writing class taught by Roberta entitled "Writing Our Lives." It was a class specifically geared towards writing autobiography with the belief that any woman's story is interesting and necessary for understanding the world we live in. Much of what I learned in that class I adapted for this project.

Inspired by current events and the discussions held in those classes, and strengthened by our experiences organizing the Peace-a-Chord Festival, Sheilagh and I decided to travel to the coastal communities of Newfoundland to interview and photograph older women.

We wanted to collect and preserve the voices and faces of women whose experiences were vital to our province's culture and history. We also wanted to experience, for ourselves, a culture grounded in fishing, before it changed forever.

We spent two summers – 1990 and 1991 – travelling Newfoundland in a bright red Rent-a-Wreck van. Armed with camera and tape recorder, cassettes of our favourite music, journals, sleeping bags, a two-*woman* tent, and a bottle of single malt scotch, we headed out into the great unknown, travelling from the Avalon to the Great Northern Peninsula and to the communities of the South Coast.

I didn't have my license. Sheilagh drove the whole way. It didn't occur to me at the time what a long haul that must have been for her. I asked her about it when we were discussing this publication.

"I didn't mind," she said. "I love to drive. I think part of the charm was that we didn't know what we were doing. It was really such a huge adventure. Places we had never been before and having no idea about them."

We drove at night on the highway only once. I think it was somewhere near Terra Nova. It began with a small creature shooting across the road in the headlights. Then we saw something a little bigger.

"Our eyeballs were on the windshield," as Sheilagh put it.

We pulled into a gas station off the side of the highway. It was a rest stop for truckers and we spent that night in the parking lot sandwiched between two tractor trailers.

We slept in the van when it was raining and slept in our tent when it was dry. We washed in streams and swam in the ocean.

We ate fish on the road, but mainly subsisted on dried refried beans. Just add water. We cooked them on an open fire like two cowgirls.

We had bags and bags of nuts and seeds. We never ate meat. We were vegetarians.

We had some ideas, but no real destination. We often entered communities blind, asking someone

working at a gas station or a corner store if there was a woman we might talk to. If there was a bed and breakfast, we stayed for a night and found contacts that way.

We drove through the diversity of the country: the coastlines, rolling hills, farmland, mountains and tiny islands and wonderful people. No one turned us away.

When we returned home, we exhibited this project at the LSPU Hall gallery in St. John's. Next to Sheilagh's portraits of the women, short excerpts from their stories hung. Their words were shot to film and printed as negatives. Then they were mounted on the glass of old storm windows and hung from the ceiling. The words were transparent.

Those two summers bridged two very different times for Sheilagh and me. The first summer on the road, we drove back to St. John's for the weekend of the Peace-a-Chord Festival but it was one of the last we were a part of. The three handsome sons formed a band and moved away. We spent less time with one another. Our group slowly disbanded. The blue house changed.

That passage of time bridged two very different islands as well – the island that existed before the cod moratorium and the island that existed after. The change was palpable.

It also bridged generations. We were urban young women who had spent very little time in rural Newfoundland. We were influenced by what was happening in the world around us yet we knew nothing of our own backyards.

Many of the women we met were self-sufficient, raising large families alone while their husbands were away fishing. They tended their own gardens, sheared their own sheep and milked their own cows. Most were born by midwives and had their children by midwives. Many never finished school and began working as young children, either looking after siblings, working on the flakes or working for other families housekeeping.

Some, like Beatrice Sibley, were shy and reticent about their lives. Minnie White sat up for an evening telling us colourful stories about being a female musician on the road but would not let us tape-record it. She gave us a biography she had written herself instead.

All the women we met shared unique life stories that were filled with hard work, love, heartbreak, and family. They voiced strong opinions about what was happening to this province and felt real concern

for its younger generations. Through them we caught a glimpse of what it might be like to be a woman growing up in an outport community.

Island Maid is a chronicle of our journey. Taken from recorded tapes and our journals from those two summers, it is a feminist road trip that documents, with pictures and words, the thoughts and lives of the eleven women we interviewed and our own experiences along the way.

Every woman has a story.

Jamestown

UNLIKE MUCH OF the rugged coastline we travelled, Jamestown was soft and sheltered. Flat, green and bucolic. Rolling hills held meadows, and farmlands ran down to pebble beaches. Not much seemed changed since it was first settled. The roads were still unpaved and there were many domesticated apple trees growing wild. Before Confederation a lot of St. John's apples came from there.

Jamestown held the only contact we had made before setting off. A friend gave us the name and address of a family who lived there. Because we had set out to meet older women, we assumed that we were meeting an older family who had lived there most of their lives. What we found was quite different.

After receiving complicated directions from a few people, we finally found the place we were looking for. We drove up a narrow dirt road until we reached a small clearing. There was a barn where two young women in greasy coveralls were working on an engine under the hood of a car. They gave us the once-over then welcomed us graciously and brought us up to their homes.

At the end of the path there was a clearing. Two houses faced each other across a large shared garden. A large pine tree stood in the centre with a tire swing hanging from it. Near the back of their land was a homemade wooden playground where there were young children playing. Their blond hair was bleached white from the sun.

Sheilagh remembers them perfectly. "The children were incredible. They had platinum heads of hair with extremely short bangs. And the most beautiful bright eyes. They had an air of confidence and security. They took our hands and showed us around the chicken coop and the playground."

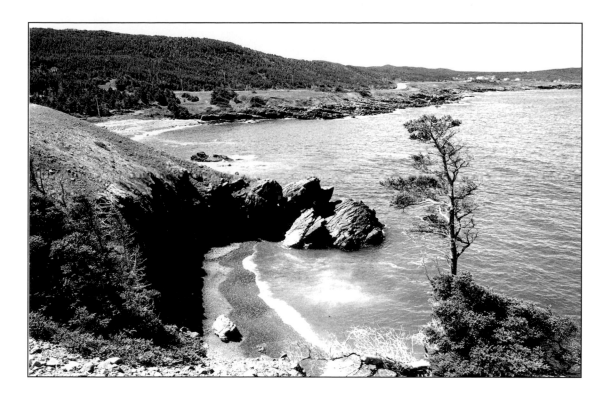

We stayed for supper that evening and they contacted a woman for us. Afterwards they brought us to a grassy field by the ocean where we set up camp. The next morning we awoke to a light rain and made a cup of tea and a pot of soup. We washed in a swift stream ten feet from where it dropped into the ocean. The children came down, took us by the hand, and brought us see to Olive Blundon. She was the first woman we spoke to.

Olive was born July 23, 1920. She and her husband Reg were kind, gentle people. Reg had been a logger most of his life and, at the age of seventy-five, still chopped his own firewood. There was a large store of perfectly cut junks stacked neatly around their home. They invited us inside the house they had built themselves from local pine. Olive gave us tea and sweets and generously began telling her story.

Rolling hills held meadows, and farmlands ran down to pebble beaches.

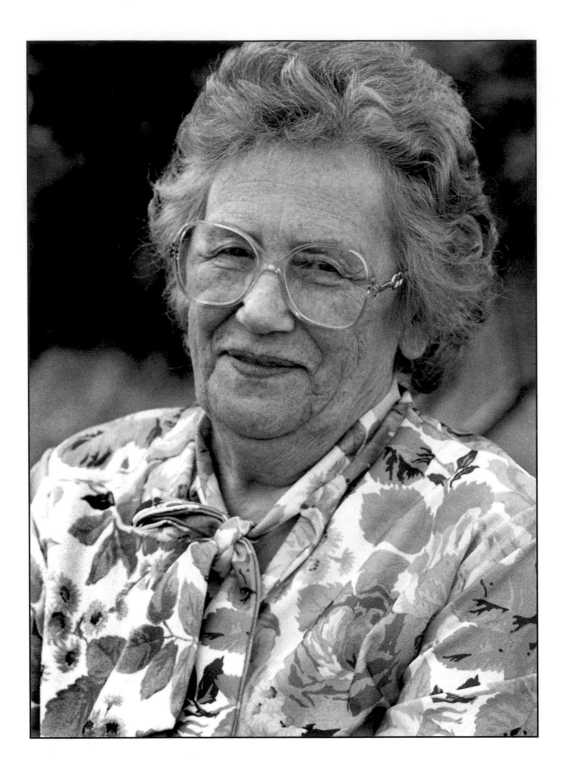

Olive Blundon

Jamestown is not like the city. Out here we take our time. The city is a rat race. You can't think. Some people come here from the city to build their cabins. They bring their skidoos and things but they are not relaxing. They don't know how to live. Not like my husband who went into the woods to make a day's living. He cut logs all day long, and in the evening when he got home, he was so tired. I always had a good dinner waiting for him and then he went to bed. We've always enjoyed our meals together.

I was twenty-eight when we were married. That may be old but that was quick enough for me. Marriage never did agree with me or anyone who belonged to me for that matter. I guess I just met the right man. I met my husband through my father. He came to visit our family home. Dad knew him long before I did but he didn't pick him out for me. My father just knew my husband was a good man. He knew he wasn't a drunkard.

My full name is Olive Dawn Blundon. I grew up in Valleyfield. It was just off the north part of Bonavista, near Wesleyville and Badger's Quay. My grandmother was born in a place called Pool's Island just down from where we lived. It was on the outside of the island and people settled there first because of the fishery. Later they all moved inward to Valleyfield. The weather was warmer there.

We looked up to our grandmother. She was a strong woman. Her husband was killed in the mill in Grand Falls when he was only forty-two years old. My grandmother had eight children she had to raise by herself and she brought them all up with hard work. Her five sons worked the schooner then. My father was usually the skipper.

My father fished all his early life. He went out on the Labrador fishing when he was seven years old. His father was still alive at the time, and my dad always went with him. Dad cut the tails off every fish they got and when he got home, the tails would be his share. Imagine, a little seven-year-old boy working like that. Most of the boys did it. They'd be seven, eight, or nine years old when they went out with their fathers in the schooners.

When they came home, their boats were filled with quintals of fish, barrels and barrels of it. The women washed it all and dried it. They got ten cents a quintal for it. Eventually, it went up to fifteen cents and that would be their spending money. That was all they had to call their own. It was really something to see all those women out on the flakes. It seems so strange to me now knowing that the flakes are all gone.

We kept a small general store in Valleyfield and I worked in that as a child. They gave me little jobs to do or I took care of my brothers and sisters. I rocked their cradles. I made fish and I picked berries. I would bottle them and save them for the wintertime. We had gardens. We never had cows. There was no grassland but we managed to keep sheep and hens and ducks.

The women made everything; they sewed clothes, hats, and coats. They spun their own wool and made sweaters. I learned how to sew really young and I made my own clothes but what I really loved doing was making cape hats. They were the oil hats men wore fishing. I made them out of flour sacks. I could cut a pattern as easy as that. I was only twelve years old.

All the fishermen came for them. I made my hats for several people. I loved to rub the oil in the material and watch it dry in the sun. I'd give it coat after coat. My father was so proud of me. He loved my cape hats, but my mother discouraged it. She couldn't understand why I liked doing that instead of making dolls' clothes. She thought I was too fascinated by it.

I also greeted men who came in collar. Now that may sound funny but it meant that your dad was getting ready to go out fishing and he had a crowd of men with him. The women in the house had to cook the meals for the eight or nine that were on his crew. I had to come out of school to help my mother. There was no other way.

All the children worked. We had to. We understood that there was no such thing as saying, "Well, I don't want to do that."

You were expected to do it and as you got a little bit older, you were expected to do more. One of the handicaps of this of course was that you could never go to school until the fishing was over. It usually came in during September or October and everyone who could work had to help out. We never went back until after Christmas.

Our school was a one-room school. When you went in the morning, you carried your fuel with you. Everyone took a couple of arms of wood for the fire. We had teachers of English descent and they were very hard. You got the strap when you didn't behave yourself. The teachers we had in our little school in Valleyfield, we were so scared of them that we just sat there, we didn't carry on. That is how we learned. The few years that we did get in school, we really learned.

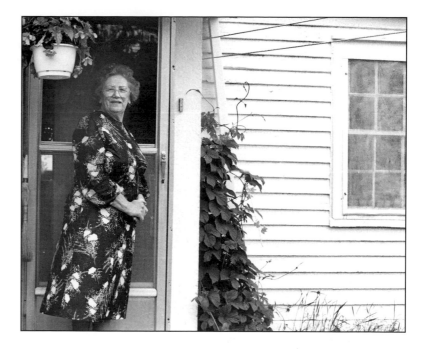

Every child was baptized. We went to Sunday school and Bible class. In Bible class we had a man teacher. Women were not permitted to read the Bible aloud. Women didn't speak in our church.

"Jamestown is a small place. You get to know everyone quickly. We love people here."

We had a long way to go to attend church. We crossed the water by boat in the summer and we walked across the ice in the winter to get there. There were a lot of places we could only get to by water. We could handle a boat as quick as you could handle a soup spoon. We had little dories for crossing the harbour and a motorboat that went to Labrador with the schooners.

We had a midwife on the island but no nurse. There was a nurse in the Wesleyville area but she was too far away from us. We didn't have much to do with her.

It seems like we didn't have much sickness apart from a cold. Our grandmothers would grease our chests with goose oil. They got every bit of oil from the geese they had and saved it for us. It kept our chests warm.

We had measles and mumps and things like that but there was never a doctor for it. There were no needles, no shots for diseases. Our grandmothers and mothers took care of all that. If someone had a broken bone, there was an old woman who came and put splints or bandages on it.

There was always someone in the community, even if death took place. The funerals were very respectable. There'd be someone to make a beautiful casket and someone to lay them out. I guess it was the same as it is now but it was done by the people then, together. We took care of all that ourselves.

If someone was really ill, they would have to wait until the doctor came. Doctor Caines was about twenty miles away. In the summertime, he reached us by boat and in the wintertime, by horse or dog team or however he could get there. Sometimes, if it was an emergency, the men rigged up a sleigh like a bed and brought the person over to him.

The worst thing we had to deal with in Valleyfield was tuberculosis. In our family, we were lucky, but I had two cousins who had a brush with it. A lot of families came down with tuberculosis. I think it was due to not having enough good food.

That was during the thirties when the fishery went down. It went down to nothing. People got rid of their schooners. Some kept their boats and still fished but the price was gone. People were under-nourished and there was a lot of TB. We got through it by helping each other. There was always someone in the community to take care of you when you were ill.

People were very caring. I never met anyone who wasn't caring. You wouldn't find a more loving people than the people of Valleyfield. It all went by the wayside when the fishing stopped. People started moving inland. They had settled there because of the fishery and afterwards it was too hard to stay.

Thirty-nine years after we left, I went back. I couldn't believe it. All the stages were destroyed and the houses were just gone. They were such beautiful big, old-fashioned homes. People took such pride in them. There used to be a fish store and a place to store your winter food.

There was absolutely nothing left. I just stood there and stared. It looked so strange to me to see it all gone. They say there are alders growing there now. There was never any when we were living there but now they say the trees are growing right out of the salt water.

I was sixteen years old when we came to Jamestown. After the fishery went down, Dad went to work for the A.N.D. [Anglo Newfoundland Development] Company as a logger. He was camp supervisor.

We were a lot happier. There was more wood and it was warmer. The transportation back and forth was better. The train was on the go then and there were roads. We didn't feel so isolated. Women worked on those roads then. They took buckets of gravel and built them up. The roads went right into St. John's.

"Dad went to work for the A.N.D Company as a logger. He was camp supervisor."

Shortly after we moved, I went to St. John's. I began work cooking for a very rich family. I stayed with them until during the war. Then things became too crowded. St. John's changed for me and I moved on to Halifax. They were not so English there. They were not so uppity.

In St. John's, you had to behave just so. It was far more relaxed in Halifax. I did the same thing, cooked for a family and I took care of their little boy. They were beautiful people. They took really good care of me. I loved every minute of it.

A few years later, I came back to Jamestown, I met my husband and that is when my life changed. We have been married over forty years and we have been living in this house for most of it. Our daughter just came home recently. She took over the rural development program here. She's enjoying it. She plays softball every night. She's always on the go. It's good to have her here.

Things haven't changed too much since we've lived here. Christmas time is still a family affair, like it always was. Mainly, it's the forestry and the fishery. The fishery is gone and it will be the same with logging if something doesn't soon happen. Chainsaws are the worst things invented. They have ruined all our country. So have the ATVs. They are not our choice of transportation.

We have too many moose now. There was a time when we never had any. They come into our garden and eat everything. They're just not taken care of. That's the government for you. It's a torment. People are getting killed on the roads because of them.

My husband is seventy-five and he still goes in and cuts his firewood. He stacks it in the garage out of the weather where it keeps nice and dry. We have a wood fire in the day but we never keep it in at night. We have electricity for that. We got our electricity twenty years ago. Before that, we had an oil burner and that was all we used. We thought it was safer than wood back then because there wasn't any flame.

We still put in a small amount of gardening: potatoes and flowers, carrots and beets. We have nice black currants that grow wild. We have a lot of apples too. Last year they took a rest but I'm sure they'll be back again this year. We give a lot of our apples away. Neighbours come and get their whole winter's worth. That is how it is here. We share.

People still do their birding in the wintertime. They hunt terns and ducks and we still hunt rabbit but you got to have licenses for everything now. We never had to before. We didn't know anything about that.

We still attend our church. It's mostly older people now; the young don't go as much. At one time there was only the United Church here. We have three religions now: United, Salvation Army and Pentecost. They all get along very well and that is rare. Our Pentecostal neighbours are good neighbours. People come to our church and we go to theirs. We really mix. There are socials and we have our church supper. All the churches participate in that.

If there is a wedding, everyone is invited. When I was a little bit younger I always made the wedding cakes. I never charged for it. It was my gift to them. I really enjoyed doing that. I always made pretty cakes.

The younger ones will come and help the pensioners with whatever they need. They will clear away the snow with their ploughs in the wintertime. The older ones always have someone to help them. They are like that. Jamestown is a small place, about forty-three homes. You get to know everyone quickly. We love people here.

Olive Blundon was born in 1920 and passed away in 2006 at the age of eighty-eight.

"We have three religions here now and they all get along. We really mix. There are socials and we have our church supper. All the churches participate in that."

Change Islands

AFTER THE NOISE of the ferry's engines had died away our first impression was the silence. It was the natural quiet of a pre-industrial world. The only sound was the rushing of wild winds. A cloud of golden dust illuminated by the setting sun chased our van along the twelve-kilometre dirt road running between dense woods. We crossed a long narrow causeway and beheld a cluster of tidy homes nestled between two coves. We had arrived at the beautiful settlement of Change Islands.

We immediately went to Beulah Oake's bed and breakfast. A grand house, the Seven Oakes Inn and Cottages sat atop a hill with an imposing view overlooking the community. Beulah had recently bought and restored it. The dining room walls were rich oak panels and the five bedrooms were expertly wallpapered. The dining room table was covered in fresh, white linen. Like Beulah, everything was spotless and organized.

In the reception room lay yellowed copies of the British magazine *The Girl's Own Paper*. Published between the 1900s and 1940s, it was filled with short fiction illustrated by etchings, advertisements for household products, seasonable styles, poetry and commonsense advice columns such as an article entitled, "Healthy Lives for Working Girls." A survival guide for spirited women.

Beulah had the indomitable spirit of a one-woman army. She manned the phone, did the cooking, hung the clothes she'd washed, and dressed up fancy to entertain and serve her dinner guests. Dinner was a gorgeous salmon dinner, dessert and tea on her very best china, all flavoured with Beulah's constant wit and humour.

She agreed to an interview but wouldn't let us pin her down. We chased her around the house, and

between baking the bread, talking with her guests, and a dozen other duties, she told us her story. It was easy to see that Beulah was never a woman to let obstacles hold her down.

Beulah insisted that we meet the sweetly smiling, giggling and blushing Bessie Hurley whom we visited later that day. Bessie was seventy-two when we spoke with her. She and her husband Leo had been married for forty-eight years. As a midwife she'd birthed one hundred and six babies and was unabashedly open to discussing how babies were born.

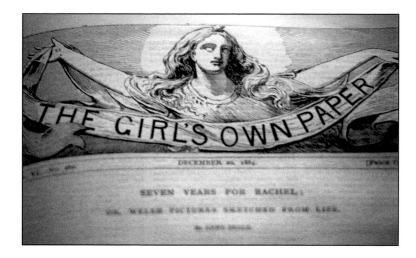

When we walked in, her husband, a shy man, took off. He stood across the street in the rain and waited. He wanted nothing to do with us.

That didn't faze Bessie. "Don't mind my old man," she said, squeezing both of our faces with her two hands. "Have a cup of tea and a piece of cake."

She fed us apple pie, date cakes, and tea every time we went over.

That evening we drove around looking for a spot to pitch our tent, but there was nowhere to hide. In such a small community anywhere we parked was too close to someone. We chose a place just off Bessie's, up a little hill, next to a boarded-up house and slept in the van. The next morning we heard a tap on our window. It was Bessie looking for our laundry.

While we accepted a cup of hot tea and a slice of pie instead, her husband warmed up to us. He teased and joked with us while he tickled Bessie, whom he couldn't seem to keep his hands off.

But when we mentioned the fishery the weight in his body shifted.

"The draggers killed everything," he said.

In the reception room lay yellowed copies of the British magazine 'The Girl's Own Paper' - A survival guide for the spirited woman.

When we mentioned the fishery, the weight in Leo's body shifted. 'The draggers killed everything,' he said.

They were trying to keep their fish plant open but no one was fishing. They were trucking it in from Twillingate to be processed.

That night, we slept in the school parking lot. A young crowd pulled up next to us. There was no bar, they told us. The churches on the island stood against it. There was no liquor store. They bought beer and hung out in the woods together. There was no police. They had nothing like that to worry about. When they finished school, they were leaving. If anyone wanted to stay, the only thing they could do to make a living was fish and no one wanted to. Besides, there wasn't any left even if someone did. There were no other options.

We spent our last day with ninety-two-year-old Flora Whitt, the oldest woman in the community, a tiny woman with a beautiful smile. Sheilagh remembers, "She was just a wisp with all her wits about her."

There were framed pictures all over Flora's house displaying children of all ages and relations. Her kitchen had a window that looked out onto the road and across the tickle. Her face was etched with the lines of ninety-two years of experience, but despite all the negative talk about the fishery, she had something positive to say about everything.

Before we left the island Beulah sent us off with a cod dinner and a goody bag filled with homemade bread and jam and cookies.

I remember the evening we left Change Islands headed for Farewell. The ferry to Farewell arrived early next morning so we drove through the night to meet it.

As we were leaving, night fell and we left behind the lights of the community. By the time we reached the centre of the causeway, it was pitch black. A sliver of moon glimmered in a universe of bright stars. On the tape Marianne Faithfull's gravelly voice was whispering, "She moved through the fair," in deep, breathy incantations. On each side of us, dark water shimmered while the road ahead fell away into blackness.

Creeping slowly forward, we had an overwhelming feeling that we were driving straight into the ocean. Travelling without bearings, beneath the starry night, with Marianne's sad song unrolling, we were like lost sailors in a safe boat floating upon the sea.

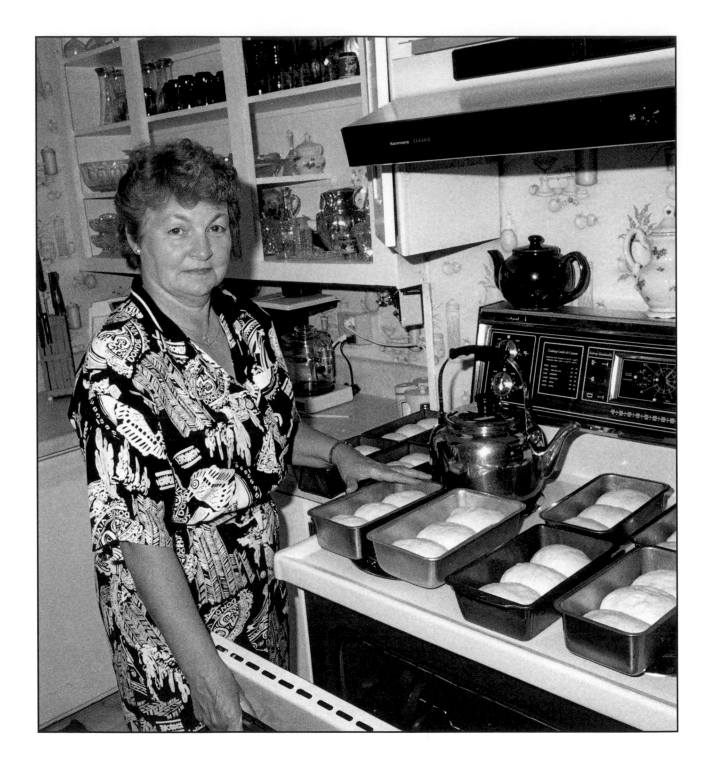

Beulah Oake

I was born on Edwards Island, which is a little island off Change Islands. It is separated by a little lake of water and when I was growing up the only way of getting between the two islands was by rowboat or motorboat. I was born there September 19, 1937. We moved from there to the main island when I was six years old and my parents decided it was time I started school. We settled on the south side of the island at Skinners Harbour and that is where I lived until I was sixteen.

I was an only child until I was ten years old. Then my mother had four more children, a boy and three girls. I took care of them most of the time because my mother would be curing fish. The fishermen would bring the salt fish to the women all around the island and they would wash it and put it out to dry on the flakes. While my mother was doing this, I was taking care of the children. In those days women did a lot more work than the usual housework and taking care of their family. My mother depended on me because I was so much older than the others. I helped wash all the clothes with a washboard and tub, cleaned the lamps every day, and brought our water in buckets. The clothes had to be hung on the line to dry since there was no such thing as washers and dryers. You just learned to work the hard way. I wasn't the only one – all the kids in the community worked, especially the oldest ones. We all knew what it was like to work and go to school.

But sometimes I think my mother expected too much from me and I felt I worked more than my friends did. I had to work when they could go out and play. My mother was an extremely clean person and it felt like whatever I did was never good enough. I remember at one point she broke her leg and had a cast on so she couldn't do much. This one day, I was on my hands and knees cleaning

the floor with one of those galvanized buckets and a scrub brush. I had the floor just about finished when my mother came in and scolded me because I didn't move the chair to wash behind it. I was so fed up with her complaining that I took the bucket of water and threw it all over the floor. The whole works! Then I ran to my grandfather who was living next door and he came to my defence.

My father, on the other hand, was a very compassionate man. He would do anything for me. He would get up and make my breakfast in the morning and walk me to school when it was stormy, walking in front of me so I wouldn't get snow in my boots. Sometimes he took me on the horse and cart. My father was home a lot because he worked for the Co-op on the island. When he was home he helped a lot around the house, where most men didn't think that was their work. He was a cook on the boats for the Department of Fisheries before he retired.

When we did get some free time we entertained ourselves – we were never bored. As small children we played house (copy house). In the summer, we would swim in the cold salt water or row the rowboat around the cove. In winter we skated and had a sled for sliding. I also had a small pony and a sleigh so we could go for a ride, kind of like they do today in their cars. The older kids would sometimes skate from Change Islands to Fogo.

Altogether my mother had nine children. With three of them she was pregnant the same time as I was. I was living in Gander then, but I didn't feel at home. Except for my husband, I was alone. I didn't have any friends and I couldn't go to my mother because she was having her own children and she wasn't in the same community. It was difficult to get back and forth, not everyone had vehicles like they do today. The only relative I had there was Eddie's Aunt Janet, who was very good to me, even though she had a very large family of her own. Usually moms like to be around when their children are having babies, but I had mine alone. That's why I have made a special effort to spend extra time with my children, and to be there when they were having their children and I try my best to be there whenever they need me.

I think trying to be a good parent is very important. I didn't always do the things that should be done, but hopefully I will pass on to my children more of the good than the bad. They say we take after our parents and my mother taught me to be a perfectionist. I find it difficult sometimes because I expect people to be the same way. When I find sheets and towels have been put away in the closet and they have not been folded with the smooth edge pointing out, I'll get them all down, fold them again and

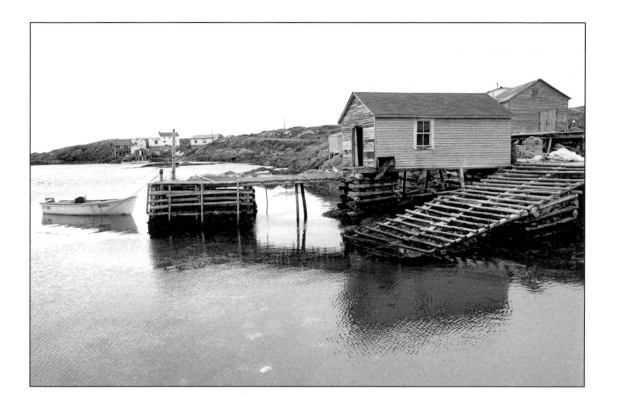

put them back. Eddie just laughs at me and tells me not to be so crazy – I'm only making work for myself.

I met my husband when I was about fourteen. We were in the Fishermen's Hall at my cousin's wedding. The teens usually sat up in the gallery and he was with another girl, but he kept trying to sit closer to me and finally he did. Shortly after that, one day I told my mother that I would someday marry Eddie. I would come out of a meeting with the Canadian Girls in Training at the United Church and he would be there waiting to walk me home. My mother never wanted me to go out with Eddie – we were United people on the south side and he was an Anglican who lived on the north side. She was dead set against it – we were supposed to stay with people from our own church. But I didn't listen to her and when I was eighteen we got married on April 11, 1955. It was Easter Monday, a holiday weekend and Eddie couldn't get any time off

"In the summer, we would swim in the cold salt water or row the rowboat around the cove."

and he couldn't afford to take the time either. We were married in the United Church in Gander by Rev. Freake, who was originally from Fogo Island. Today, my mother thinks just as much about Eddie as she does me; and she did til the day she died.

During the early years of our marriage, my husband and I moved quite a bit. In those days there was a gravel highway – the paved TCH [Trans Canada Highway] came much later – so rather than drive, we put our belongings and our car in a boxcar and had it shipped. The road was terrible. You would go over mud holes and get stuck and have to wait for somebody to come along to help you push the car. You'd get out of it and drive along and maybe help the next person. It was unreal.

When we lived in Gander, I went to work at the airlines hotel and Eddie worked at the Goodyear Humber store. We had three children. Then we moved to Lewisporte. My first daughter was born there. She was the first girl to be born into my husband's family in many years so she was very, very welcome. She was only three or four months old when we moved to La Scie, where Eddie worked with Maritime Mining. We lived there for five years and I had another child. We then moved to South Brook [Pasadena] where Eddie worked for Newfoundland Air Transport [NAT] for one year and then moved back to Lewisporte. We finally settled in Deer Lake and bought a house. We live in that same house today. It was there that my husband began working with a small airline company and learned his trade as an aircraft engineer. He has been there ever since. Eddie has never lost a day's work in his life and he has been a very good provider and a wonderful father and grandfather.

I began working at the Deer Lake Motel, where I worked nine or ten hours a day. We didn't have to punch a clock and we were never paid overtime. We just stayed until our work was done. I was the hostess and if there were people in the dining room, I never left until they were finished. I worked my shift, came home and then did all of my own housework – maybe doing laundry til one or two o'clock in the morning. It had to be done before I went to work the next day.

We both worked hard. We had seven small children and we were trying to survive the best we could. We dressed our children as well as someone who only had one child, and by me working we could give them a little extra. When they were smaller, the boys wore their little black suits and ties to church. One of my sons played hockey and his blades were worn so much he couldn't use them but he never complained. When I knew he needed them, I saved my tips and bought him new ones so

he could be in the play-offs. Our youngest daughter figure skated and I remember paying $350 for a pair of skates. It was very difficult to come up with that amount of money but I did. We always made sure they had what they needed, no matter how hard things might have been, or what we may have to do without. They always had enough food on the table and we tried to give them what they needed, not what they wanted.

Things got easier when I ran the restaurant and gas station at the Irving. The Irving people approached me to start their new restaurant in Deer Lake. After some consideration, I decided I would give it a try. Believe me, it wasn't easy to raise a family and run a business. I had more freedom to go home at anytime if I needed to. All my children were in school and after school my sons worked serving gas and my oldest daughter worked in the restaurant. My youngest, who was about five, would come with me to my office. He would play with his dinkies while I worked.

My children never fought. I always told them to make sure they knew what they were saying before they went out the door because they might never come back. I never had to leave work to deal with them fighting. I never saw a time when they put up their hands to each other and that is a lot to be thankful for with seven children. The mothers who worked with me were amazed at how well they got along. My children would come to the restaurant, sit down and wait for their brothers and sisters so they could have their meals together.

Eventually, the Irvings wanted us to stay open 24 hours and I didn't want to do it. It was too difficult on the children and I, and it would have been an extra expense for us so I told them I would not do it. During that time, the manager of Eastern Provincial Airways asked me if I would do something at the airport in Deer Lake because at that time you couldn't even buy a cup of tea. There was a small utility room that they turned into a little canteen. I had a microwave, a coffee pot and I made sandwiches. It was a real help to the staff and passengers to be able to get a cup of coffee and something to eat.

Later a job opened as station manager with Labrador Airways. I took the position and worked there for a couple of years before they started changing their operations – handling more freight and heavy work better done by a male.

My husband and I went into a franchise business with frozen fast foods. We took the distributorship

The Seven Oaks Inn and Cottages sat atop a hill with an imposing view overlooking the community.

for this province. It was a good concept and the products were good so we invested our savings and borrowed money into the company. We had our house paid off and were in a good position to do this. We bought a freezer truck and distributed throughout the province. It was working very well, then, two weeks before Christmas, the phone rang. All the money we had invested was gone. People had disappeared with our funds and there wasn't a thing we could do about it. Forty thousand dollars, two weeks before Christmas – I nearly died.

We tried to carry on. We bought more food from another supplier but it was spoiled when we got it. They said it was fine when they shipped it to us, so we lost another ten thousand dollars. We couldn't keep going. We sold our truck and re-mortgaged our house. It was heart-breaking.

It took us a while to pay off the house a second time! We were lucky my husband kept his job. Other families involved lost their homes and were left without employment.

However, I cannot believe that now, fifty years later, I am back to my roots where we have purchased a hundred-year-old house formerly owned by a fish merchant known as the Earle property, which we have refurbished as close as possible to its original state. This required thirteen months of research and a lot of dollars to get legal title to the property. Then the structural work began and my husband, sons and hired help from the island spent many long hours on the restoration.

Our lawyer, as well as the Minister of Tourism said, "Beulah, you got some guts! If you had as much money as you got guts you'd be dangerous."

It has all become a reality with the support of our family and friends and dedicated local employees.

I have worked in the service industry my whole life and have raised seven children. My first job at seventeen was as a nursing assistant at the Banting Memorial Hospital. I worked at the airlines hotel in Gander, the Deer Lake Motel in Deer Lake, the Irving in Deer Lake, Labrador Airways, and I had a frozen food franchise. I have a lot of experience and I put everything I knew into this Country Inn.

I was the first woman to run for town council in Deer Lake and to be elected. I had no problems with the men there – there was no discrimination towards me. I was also president of the Development Association of the Humber Valley and the men there respected me for who I was. From the very beginning they knew where I was coming from.

When I ran the Irving, most of my dealings were with men as well.

It is up to the woman what sort of impression she gives and the first impression is always the lasting one.

I have never been insulted and I get along with people. I mean I can be so upset with somebody and tell them what I think of them but then minutes later I'll pour them a cup of tea. That is the way I am. With my husband, I can be mad enough to throw him over the bridge out there and I'm sure he feels the same way about me sometimes, but we never stay mad. The children laugh at us and say, "Mom, you two are just like kids."

I have no problems working with men. I respect them for what they are. We each have our place in society. We do some things better than they do and they do some better than we do. I don't think women should try to be men – if they do then they should go through a sex change. I'm glad I'm a woman and a mother. I enjoy that part of my life. I don't, by any means, envy the man's role in life – it's no easier than ours.

I think women are the stronger sex – I think we can stand more pain and we may have more tolerance because we are mothers. But women don't seem to support women and I think we are our own worst enemies. Our feelings may be too involved, maybe things bother us more, but I think if women supported women more there would be more women in politics and other public offices. I know there are a lot more women coming on stream now.

In my generation transportation has gone from dog team to the Concorde. There is no generation before us that has experienced so vast a change. I mean, that is unbelievable! And space – the man on the moon. From dog team to a man on the moon is almost too much to digest.

We always came back to Change Islands with our children for vacation every summer. They experienced the coming of electricity to the island, the construction of the road, cars coming to the island by ferry. My oldest son sat with his Grandfather Oake and watched Neil Armstrong set foot on the moon – he was fourteen at the time. He will never forget that day because as Neil Armstrong was about to set foot on the moon the TV went blank, and his grandfather was so mad that he put his fist down through the metal TV case and the TV came back on, and together they witnessed the landing on the moon.

One time, the men worked and the women looked after the children and the husband when he came home from work. Now both men and women are working and often there isn't anybody home. I think being a parent is one of the biggest challenges in life and if two parents are gone from

home, who's left there? Our society has gotten to the point where two parents have to work to survive. They come home too tired to communicate. Unhappy parents make unhappy children, who then make unhappy parents. It's a vicious circle.

We have to share the workload more. It seems we are still living in a man's world, and I don't want it to become a woman's world. I think it should be equal. I think men are the best creatures on earth – other than ourselves.

Beulah still operates the Seven Oakes Inn & Cottages in Change Islands, and since this interview Beulah and Eddie's seven children – Dave, Dale, Danny, Darlene, Dene, Diane, Derrick – have given them twenty grandchildren, who have given them six great-grandchildren. Unfortunately, Eddie passed away in March 2006 after fifty-one years together.

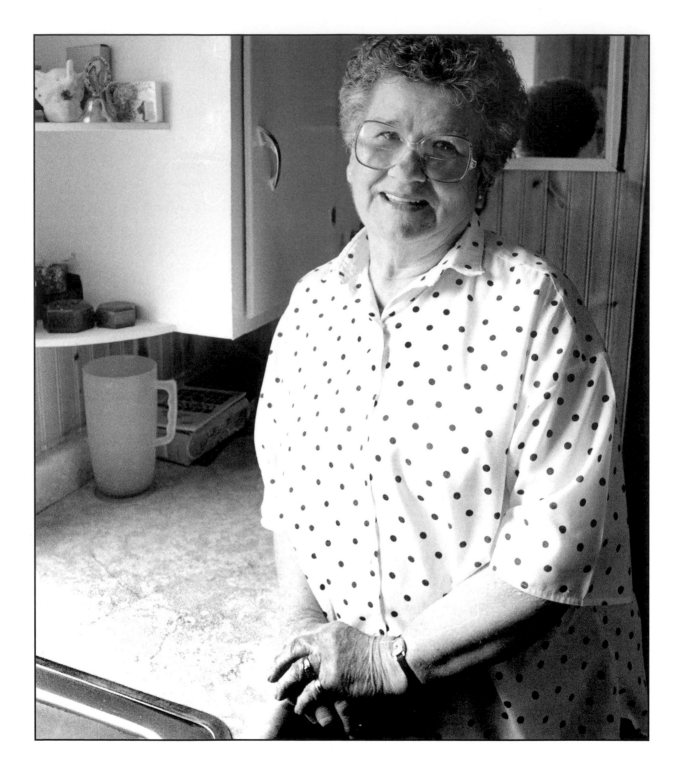

Bessie Hurley

I don't remember much about being a child but I remember that we never had any shoes on. We'd go down around the shore with our naked feet on the rocks and blindfold each other to see how far we could walk. The next thing you knew, one of us would be in the water.

The foolishness we used to get into, we always had fun. We'd stick a tree up in the sand and see who could push it down first by throwing rocks at it. Once, it was my turn to go and put the tree back up but before I got down there, I got a rock to my head and it was cut abroad. They had to take me up to Mom because the blood was running out. She cleaned it and stitched it up for me, but she laced the wrong brother for it. The one who did it got away. We were bad then, evil.

We had a big house and we all slept upstairs two or three to a bed. My parents had a lot of parties and even though we were never allowed over the stairs when they were going on, we'd always creep down as far as we could to listen.

By and by, they would find out we were there and shout at us, "Get back in that bed!"

What a time we would have!

We didn't have it quite so good as some people but we always had something to eat; Dad killed birds and seals, and we always had clothes on our backs. One would grow out of something and another would take it as long as it would last. There was no such thing as throwing anything away.

Every now and then we were given these big pennies, almost as big as fifty-cent pieces. We would go to the store down the road and get large bags of liquorice candy that were made into pipes and cigars. We had a lot of fun growing up, it was exciting.

My mother's name was Elizabeth Brenson. She was born on Change Islands. She wasn't very old when she married my father, maybe seventeen, maybe younger. She had a big crowd; there were eleven of us but everyone had big families then. They didn't know about pills or stuff like that. They just had babies! Babies! Babies! My mom had miscarriages in between some of her babies but it wasn't unusual, everyone had miscarriages a lot then. I suppose it was hard on a woman having a baby almost every year, hard on the inside. It's surprising how they carried all the babies like they did. One was born and another was on its way. It had to be hard.

My mother spent her whole life working and having babies. She scrubbed the floors every Saturday, and every week she cleaned all her hook mats before she put them down again. It was always spotless. The only time she stopped working was when she went into labour. She would be at the stage and have to come up and go to bed. She worked right up until the time she had her baby. There was never any slacking off. For all she did do, Mom lived to be eighty-three. Hard work don't hurt anyone as long as it's done the right way.

My mother was also a midwife but she never trained for it; she never went to any hospital. There were always midwives around the island and she went along with one of them and picked it up that way. She borned a good many babies in her life, no one ever thought of going to the hospital then.

When Mom got old, the Anglican parson asked me if I would be interested in taking over. It had changed quite a bit by that time and I had to go to St. John's to train. The parson set up everything for me; he sent me to a boarding house and I had two months' training at the Grace Hospital. I didn't learn anything there that I didn't already know about borning babies but I had to get my license in order to practice. There were a lot of midwives going to St. John's to get their licenses then, the place was always filled.

In St. John's, everyone was busy having babies. They had women in labour everywhere – down the halls and in the corridors. I would look at one, then another, and then another. When one was ready, we brought her to the delivery room. Then the doctor would come in, snip the cord, give the baby back to the nurses and go on again.

It's a real experience seeing a baby being born. Some of the nurses would faint the first time they saw it but you can't take it to heart like that. The nurses were never trained to born babies and I guess they just took it for granted that the mother would be okay, but it's a big responsibility taking someone's life in your own hands. It's not the knowing what to do as it is the worrying; you never know what you're getting into. Babies come every way and it can be hard.

I remember one mother whose baby was bleeding; the nurses never had the cord tied tight enough. That's very dangerous. It's the one thing you've got to look out to. You have to make sure the cord is tied tight because they can lose a lot of blood if it isn't. I would always cut it with about an inch and a half left so I could tie it properly.

They didn't, as a rule, let midwives born babies in the hospital but they let me deliver one baby while I was there. She was a welfare patient. They didn't mind that because the welfare ones didn't have a doctor; the nurses borned their babies. I had seen babies being delivered plenty of times before so I was pretty calm and I was so into it they thought I was clever. I borned that baby and got it done all right and when I was finished, I left the room to fill out the forms.

A doctor saw me and said, "You're too young a thing to be calling a granny!"

Because that is what midwives were called back then; they were called grannies.

I finished my training and came back to Change Islands in August and I borned my first baby here in September. That was in 1950. Altogether, I have borned one hundred and six babies and that's not counting the miscarriages and women who went to the hospital. Sixty-seven boys and thirty-seven girls, two stillbirths and three sets of twins.

I remember saying to one woman who was having twins, "I got one here but there is another one coming."

She said, "Heave that one out the window!"

She didn't want to have two because babies were so hard to raise in those times.

I had one breech, his little bottom coming first. It's harder than normal because you have to get the baby's head out as quick as you can on account that it could be nipped by the cord. You have to really work it to get the baby's head out safely.

I never lost a mother; that was one good thing about it, I never lost a patient. In the last couple weeks of their pregnancy, they would phone me and ask me to come. You wouldn't know but in the middle of the night you would get a call by a frightened mother. The bridge wasn't across then so I had to go across by boat or if it was the wintertime, I went out on the ice and walked on the pans.

When they were in labour, I had them walk the room. I walked them as long as they could walk. You bear a few pains this way but it helps to bring the baby down. I knew when they were ready; I would look and see them opening up. Nearly always, the bag of water came first. Mostly, it broke on its own but sometimes I would have to break it myself.

I had eye drops for the babies when they first came into the world. I used these drops to clean out their little eyes because they had old stuff in there from their mother. And I had something to clean out the mother's womb with.

The mothers would never want anyone else in the room. That was the proper way too, one looking on is enough. Now every man goes to the hospital to see the baby being born. I think I would have drove them all out if it ever happened to me but that's what they want now. I imagine it's a big experience for the father, but it's not a very pleasant experience for the mother. That's how nature is though, hey? It's wonderful when it's over.

With every baby, I sent out forms to St. John's with all their information on it. I put the weight down, the mother's name, how the baby came, was he healthy, all kinds of questions; that was how they were registered.

I kept my own records too. For each baby I borned, I wrote the husband's name down in my black book. I have all the men's names, none of the women's, that's just what you did then. I did a lot of babies in the 1950s. In 1951, there were nineteen babies born. That was a really big year! 1952 was good too; fifteen babies were born. What did they have on their minds I wonder? They were right out for the baby bonus in those two years!

Most of the women breastfed. I did, my mom did, she breastfed for eleven children. The doctors still want you to breastfeed today if there is any way you can. It's the mother's milk, it's better for them. I think the youngster loves more if it is breastfed; it's a chance to be closer. Just shoving a bottle in their mouth and putting them down and going on, there is nothing exciting or lovable about that.

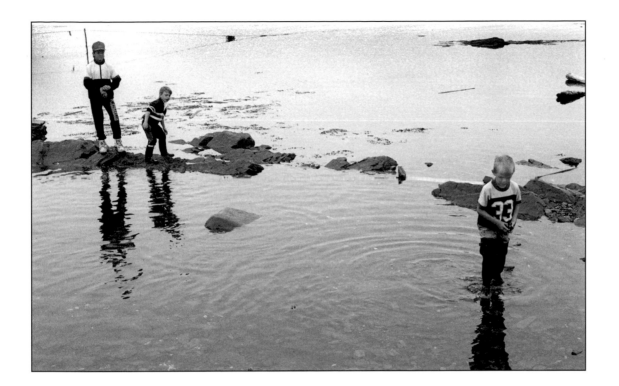

There is nothing like cuddling a little baby.

But there are some who just can't do it; they are underweight or are not able to cope with nursing. Some try it and have to give it up; their milk is just not rich enough. They would use Carnation milk if they couldn't breastfeed. I mixed it up for them. Baby's formula wasn't known about then.

Other mothers were just afraid to take out their titty; they found it embarrassing. And some didn't want to be tied down, that's the other thing. They couldn't go out when they wanted to. The baby had to be fed every four hours. That was the schedule I told them, which meant they had to get up in the middle of the night and they had to do this for nine months. Nine months is the most you should nurse a baby. By then they should be eating.

"In 1951, there were nineteen babies born. That was a really big year!"

"You wouldn't know but in the middle of the night you would get a call from a frightened mother. The bridge wasn't across then so I had to go by rowboat."

I was married for thirteen years before I had my daughter Judy. I was thirty-eight when I got pregnant and I was so happy; I always wanted my own child. I was real lucky too; I got her on the change.

I didn't marry my husband until I was twenty-four. Some girls were getting married at twelve and thirteen years old; there were a lot of them, but I just didn't bother. Finally though, I made up my mind. It's a job to make up your mind to that sometimes. You don't know whether it's the best or the worst thing to do. But that's your vows, for better or for worse. You got to take the worse with it.

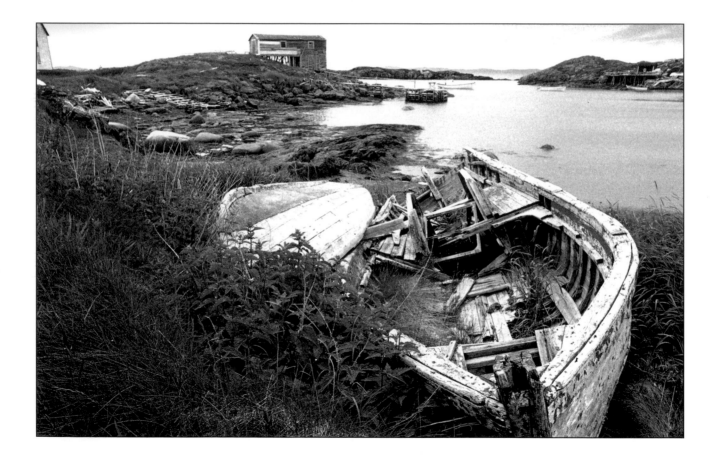

I met my husband like everyone else does, out and on the go in the nighttime. He wasn't the first one, though, you know; I had a lot of boyfriends before that but I decided on him. He is a good man. We've been married forty-eight years. I will be seventy-two soon. I suppose that isn't too old, but to some it is just the same.

I borned babies until 1977. I was sixty-some odd when I stopped. I learned a lot being a midwife; it was interesting. It is the sweetest thing in the world to see a baby coming into this world.

I don't know about doctors borning children now; I suppose they are all right but they don't do the work like they should. They only come in when the baby is ready to be born and snip the cord. They don't take time with the patients, not one bit. Midwives were more caring; they always worked like they had a life in their hands. I know women who have said they would rather have me. They would rather have me than all the doctors in the world because I stay with them until it is all over with. I don't leave them.

Someone asked me lately, if they were caught, would I come. I dare say I would do the best I could. I still have my bag packed. I have two of the machines you use to clamp off the cord so you can cut in between and I have my scissors and a fresh cover sheet. I would do it, indeed I would, if they got caught and couldn't get off the island, if it was an emergency.

Bessie Hurley passed away in June of 1996. She is buried next to her husband Leo, who passed away in May, one month before. Their only daughter Judy followed in her mother's footsteps and became a nurse.

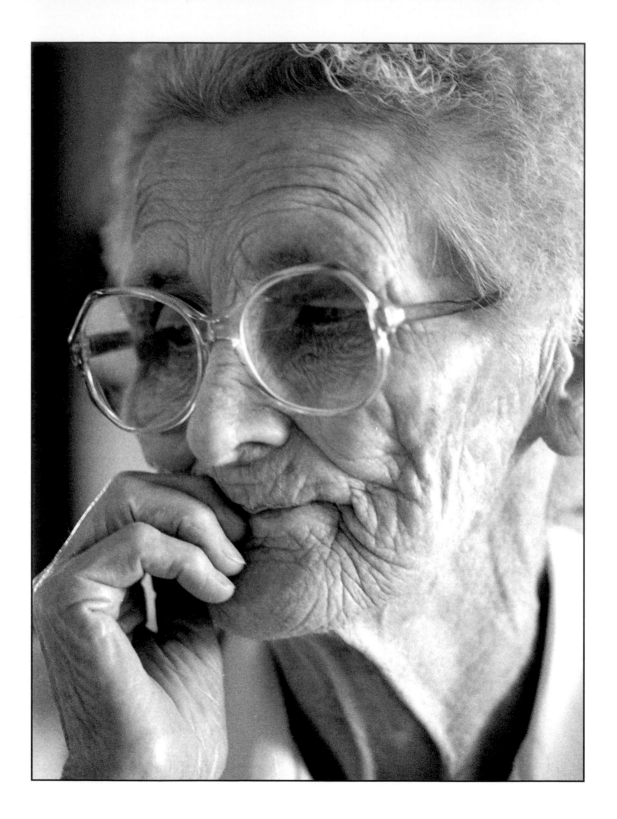

Flora Whitt

When I was eleven years old, I went to Springdale with a bunch of girls. I made a dress for myself before we left. I got a piece of material and cut it out just like a piece of clothing I saw someone wearing on the road. That is how I got into sewing.

It just came to me, I suppose. If I saw people wearing different clothes, I could come home and take my paper and material and cut it out just like what they had on. I never had anyone show me. My mother couldn't sew; she couldn't take anything, cut it out and make a garment. She worked hard all her life raising us and working at the stage, but she couldn't sew a handkerchief!

A lot of clothes I made were for children. No one could afford to be buying new clothes all the time so anything the older ones wore out they would give to me and I would cut it down to make clothes for the smaller ones.

I sewed for everyone, including men. I made their army uniforms and I made their common suits. And I made lots of wedding dresses. There is an older lady just down over the hill, Aunt Mabe we call her. Well, one of the last wedding dresses I made was for her.

I sewed by hand for years. It wasn't until I was married that I got my first machine. It was a hand machine, but I didn't like it too much so later I bought a foot machine.

I did bags and bags full of clothes for people on the island and off the island. I made a good many stitches. I got paid, but I didn't get very much money. For making a dress, I would get a dollar. You couldn't get a seam sewed for that now.

I was seventeen when I came here. My sister was keeping a house for our uncle in Twillingate, and when I was old enough, I went to be with her. Then my uncle sold his home, and we both came here to Change Islands.

Our family lived in Sandy Cove, just opposite Little Bay of Islands. There was nothing like Concorde planes or what have you when I was growing up. We had no cars. Anywhere we had to go in the summer, we went by rowboat. It was the same buying our staples; we had to go over to Little Bay of Islands. It was the only store around.

We went to school, but it wasn't as comfortable as it is now. We had to carry wood for the stove and the seats were awful. We walked a long distance to get there and in the winter we had to paddle along in the snow. We would be wet right up our legs and when we finally got to school, we'd gather around the woodstove to dry our clothes. We never got colds on account of it though. I suppose we were just brought up to it. Now the children are right comfortable going to school. They haven't got to go through no snow.

We had a lot of land and that is mostly what we lived on. We had cattle and sheep and we grew lots of vegetables. Everyone grew their own vegetables in my day. We had potatoes and turnip, carrots and onions, everything like that. There used to be lovely gardens around here at one time. Everything you could mention, people had growing. Some had it so good you could take a spoon out into it to dig up the ground. No rocks in it. Right nice. Nobody grows vegetables now; you have to go shopping up to Red Cove and bring it home in a bag.

I had five sisters and one brother. We had a big house with four or five rooms upstairs and a clothes closet as big as our porch. My father was a fisherman and my mother did her housework, tended the garden and worked at the stage. When my sisters all grew up, they left home to get work wherever they could servicing. My brother fished for a few summers and then he moved to Corner Brook when the mill opened. He worked there until he got his pension.

I'm the youngest one and the only one left. They're all gone now. So I guess I will be the next one, won't I? But I've almost always had good health; right up through I have never been sick. I was born on the eighth of November; I'd have to look in the Bible to see what year but I will be ninety-two on my birthday. I'm the oldest person on Change Islands.

I have two sons. One was born in 1925 and one in 1943. That's a big difference, isn't it? I was married for eight years before my first son was born. He was eighteen when I had my second.

I met my husband when I moved here. He was a fisherman. There was nothing else on the island other than fishing. But it was a good thing to be had at one time, there was a bit of money in it. The last few years though, it's gone the other way and there is no more around here. People now, they just work to get their stamps, it wasn't like that then.

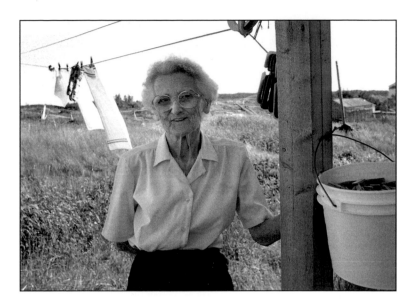

People worked hard. They got thousands of fish but they got nothing for it. We had to live pretty mean sometimes. After Confederation came in, everything, like it, flourished up. People certainly got along better.

When my husband was fishing, I would do my housework, then I would go make fish. There would be tons of fish salted away and when it was seasoned, we would take it and wash it out in a big fishing tub down at the stage. Sometimes, we used a brush like a scrub brush and other times we used a cloth. We would wash it all and when we got a fine day, we would carry it out to dry on the flakes. We would do so much, get it dried, and get more out to dry after that. Everything would be covered in fish! Sometimes, we would just get all the fish out and in would come a storm and we would have to run out and take it all up again. That would kill us.

Women worked just as much as men. The men would go and get the fish and the women would wash and dry it. All the women in the community did that and took care of their children. Today, you have to have a babysitter but we would take our children wherever we were working to. There was nothing like that then.

"Mostly, I tend to myself. I don't want anyone to tend on me."

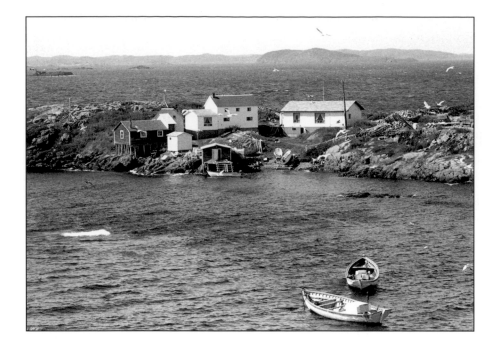

When the children were small, we would mix a bottle of milk and bring them down to the stage. There was a big table for the women to put the fish on, and we would put our children in boxes or whatever we had up there and give them their bottle or biscuits if they could eat them, and there wouldn't be a sound out of them for the rest of the day. They would sit in their boxes until we came up from the stage again.

I loved to work. When I was younger, I was a real boy. Whatever my father was at, I had my hands into. I could take a man's work onto me and go on just like I could my own. When Father put down his scythe from cutting grass to rest for a spell, I'd pick it up and go mowing. I didn't feel like my work was hard.

There are some women today who hardly do anything. They don't do a thing! They rarely do their housework and when they do, they have everything to do their work with. It's just to plug in this and plug in that. To go and sweep up, we always had to take out the broom, there was nothing like electricity. Makes them lazy, I say. It wouldn't hurt them to learn a few things before they got married. Though, I guess I didn't want anybody teaching me, but then I could do my own work! I had to work, I didn't have a choice.

I still do my work around the house. I like to keep myself busy. I still wash every dish. I could go to everybody's house and wash their dishes. I love washing dishes. I used to make bread. I mixed it up here in my kitchen, but one time when I was doing it I

"At one time you could see the schooners getting ready to go to Labrador. It was nice to watch them all go off in the wintertime."

didn't feel any sense. I barely got the dough out of my hands when they took me and put me over on the chesterfield. They won't let me touch it now.

Mostly, I tend to myself; I don't want anyone to tend on me. During the day, I take my hook and my cotton and make a pattern from my crochet. I promised my sewing machine to one of my grandchildren when I finally gave up sewing so that is what I did. I gave it up seven or eight years ago.

My husband has been dead for forty years. He was a good man. If I searched the world over, I wouldn't get no better. Perhaps they would have more money but that's not the thing, is it? It's better to have nothing if it means you'll live together happy. My husband was quiet as a mouse; there was never a word out of him. He never drank. I never had that to encounter. Never had a cross word. Lots of fighting but never a row, never nothing like that. That's rare. He couldn't have been better and I am sure that he was good to me.

I've lived in this house for seventy-three years. My husband built it when we were first married. My sons grew up here and my grandson and his family live here with me now. We have a really nice view. You can see the harbour. At one time you could see the schooners getting ready to go to Labrador. It was nice to watch them all go off in the wintertime.

I wouldn't leave this island for anything. I'm too afraid of the water. I can only just manage to go across on the boat. Everyone else is always going back and forth. They do their shopping in Gander or Lewisporte. If I were sick and had to go somewhere, well certainly, but I wouldn't go for sporting or shopping or anything like that. I've had lots of chances to go out to Toronto with my grandchildren but I couldn't make it. I couldn't do it. I have never been on a plane. I think if I had to, I would rather go by boat than by plane. I don't think I would live well in the city anyway. I get a bit lonely but I'm used to it here. You don't have to lock your doors. I suppose it's like everything else. It's just something you get used to, from the cradle on up, and then you call it home.

Flora Whitt died in 1995 at the age of ninety-six. Her son Vaughn and his wife live in the family home on Change Islands.

The Codroy Valley

HEADING NORTH ON the West Coast we climbed gradually up a long curve on the highway until the mountains stood up abruptly ahead of us. My ears popped. We decided to climb Gros Morne Mountain, the second highest peak in Newfoundland.

We rose that morning at 6 a.m. to begin our hike. The walking trail was a long winding path along the side of the mountain. We chose the cliff face instead and headed straight up through the gravel and shale. After hours of hard scrabble we reached the top and stood above the clouds. Sheilagh, like a mountaineer who stakes his claim with a flag, took off her shirt and waved it around in triumph.

At that moment a group of geologists dressed in knee socks and Tilley hats, like characters from *Monty Python*, popped up from the cliff face. Their first sight was Sheilagh, shirtless, with all her bounty swinging in the wind.

The next day we drove south to the Codroy Valley and the mountains rolled away behind us. It was a hot day with no wind under a cloudless sky. Everything seemed stilled and slow. Sheep and cows grazed in the meadows and hid from the heat beneath old barns. An old yellow school bus on the side of the road was stacked with winter firewood. Tractors stood idle in the middle of untended fields. An old blue pick-up truck with a wooden corral built on the back was slowly driving up the road. The driver's arm hung out the open window, holding onto the rope of a tethered bull that walked languidly along on the grass beside it.

We stayed at the provincial park. There were showers there and we were desperately in need of one. Too tired to set up our tent, we slept in the van that night. It was hot, humid and suffocating. We

awoke in the morning to the sun focused through the windows like a tight ball of fire. The van was a bread oven and we were stuck to our sleeping bags.

We drove to the lighthouse at Cape Anguille, the most westerly point in Newfoundland. *Anguille* translates from French as "place to launch boats," and it was easy to see why it was so named. A golden stretch of sandy beach seemed to go on forever. Tired and stiff, still half-baked from our sleep the night before, we dove in.

Later that day we met a man who was trying to develop the area's tourism. Many people in the Codroy Valley were rejecting his plans for development. They said they did not want their home turned into a giant resort. He had land and offered us a place to pitch our tent. It turned out to be directly behind the Codroy Valley Folk Festival beginning later that evening.

The Codroy Valley Folk Festival.

We spent the entire three days at that festival. There were men getting up on stage with small wooden platforms under their arm. They stood on these little platforms and step danced against one another. They held their torsos perfectly still and swung their hips. Their feet tapped to the fiddle as fast as lightning.

Older couples waltzed on the grass. I remember seeing a tall man with a tangle of hair piled on top of his head. He was thin and rangy and dressed in a cheap, brown polyester suit. He stood apart from the crowd. I am still convinced it may have been Tom Waits. He was the spit of him but we were too timid to ask. We danced late into the night, every night, and then we crawled into our tent right behind the stage.

We met Minnie White at the festival.

After she performed we asked her if she would let us interview her. She agreed to talk to us as long as we didn't record her. We went to her house in the evening.

Minnie was fabulous. She gave us food and we drank rum together. She shared stories of being on the road, of spending time away from music to raise her children, and of deciding to return after her husband's death.

"She had bright eyes that didn't miss a trick. She was very acute and I could see it in her glance," said Sheilagh. "She dressed very sexy. Cool satiny dresses with spaghetti straps in burgundy colours, heels, jewellery, and her hair neatly braided over the top of her head."

We stayed into the early morning. After the three days at the festival, Sheilagh and I were worn out but when we left, Minnie was still going strong.

The next day we went to the Starlite motel: "Home of Minnie White and the Boys," a banner proclaimed. Memorabilia of Minnie were all over the walls. Hanging on the inside of the bar amongst the bottles of liquor and cigarettes was a framed picture of her standing majestically with her arms stretched out toward her "Boys." Minnie was posed for eternity in a salmon-coloured gown with flowing sleeves, flanked by her band. The "Boys" sat around her dressed in identical shirts and pants like a uniform. They were like Minnie's private infantry. Above the photo a banner read "Minnie White and The Boys, Sunday 3 to 6." It was her shrine.

On our way to Bay St. George, we drove toward Port aux Basques to see the twin hills. Minnie had told us about them and said they were affectionately known in the area as the Swinging Tits. This held a special meaning for Sheilagh who had set her own free on Newfoundland's second-highest peak a few days before.

The Twin Hills, known in the area as The Swinging Tits.

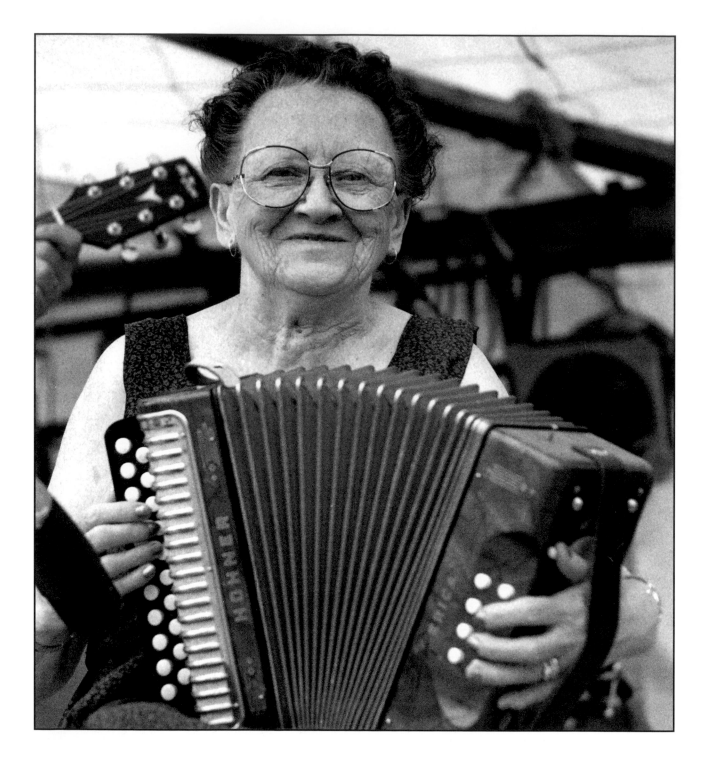

Minnie White

Born April 1, 1916, at St. Albans, Bay d'Espoir, to parents of Irish and English descent, I was influenced by my father who played music. Being a lover of music, I began playing his accordion at the early age of eight; music I learned by watching and listening to him.

Being of Irish descent, I am more inclined toward this type of music but I enjoy and play all types, such as Scottish, folk, Newfoundland and some good country rock. I play many instruments: mandolin, violin, accordion, and keyboard. Of course the accordion is my main interest, and given a second choice, it would be the keyboard. I played piano with the fiddlers in the Codroy Valley years ago.

Entertaining people has always brought great joy to me and in 1973 I decided to go into the music business and record my first album, known as *Newfoundland's First Lady of the Accordion*, featuring some of my own material like "Little Wedding." The album also featured an old jig called "Sally's Jig," which at the time was never recorded by another musician.

In 1978, I recorded my second album and this album also featured some of my own material such as "The Starlite Afternoon" and "Midnight Waltz." I recorded a single, "Mountain View Valley," that I had written and composed.

My involvement in music has taken me to many different clubs and places. I have played in Sydney, Halifax, Lunenburg, and Nova Scotia. In Newfoundland, I have travelled and played in Ramea,

Belloram, Bay d'Espoir, St. John's, Port au Port, Stephenville, Piccadilly, Corner Brook, Isle aux Morts, Codroy and Port aux Basques.

I played for thirteen years at the Starlite lounge in Thompkins every afternoon on Sundays from three to six. The club filled to capacity with young and old. I knew how much I loved playing for them.

I have appeared on shows with the CBC TV namely, *Canadian Express* and *Root Cellar*, and with CBC radio, *The Newfie Bullet*, *Variety Tonight* and *On the Go*.

In the winter months I very seldom play. I enjoy this break from music as it gives me time to do some hobbies I enjoy, like crocheting and knitting. It is also during this break from public playing that I practice my music and write new material.

The key to all musicians is to like what you are doing and like doing it for others.

Minnie White was born in 1916 and passed away in 2001. She was eighty-five years old. Her music lives on in recordings and tributes at folk festivals throughout the island.

Memorabilia of Minnie were all over the walls. The Starlite was her shrine.

Bay St. George

WHEN WE ARRIVED at the Bay St. George senior citizens' home, we still hadn't recovered from the Codroy Valley Folk Festival and our night with Minnie White. We thought we might make contact with someone and return the next day for an interview.

We asked the nursing supervisor if she thought there was a woman who might talk to us. She took us to see Sarah Benoit. We followed her down the pastel-coloured hallway with patterns of ptarmigans and sandpipers on the walls. In the common area was a fish tank, two budgie birds nuzzling in a cage and ninety-eight-year-old Sarah sitting by a table.

When we told her what we were doing, she started up. Sarah was fierce, strong and independent. A real fighter. She told us she had to fight to get in there. She had been ninety-six years old when she applied but they thought she was too fit for a senior citizens' home. She had to fight to get the place carpeted. It used to be cold concrete and linoleum. The managers wouldn't listen to her so she wrote her MHA.

Her story came rolling off her tongue but we weren't prepared. Sheilagh didn't have her camera and I didn't have my tape recorder. We explained that we'd had a long journey to get there, that we'd rest up and be back the next day.

We pitched our tent on a beach, washed in Black Duck River, rustled ourselves up some refried beans and slept soundly through the night. The next morning we made pancakes on our Coleman stove and watched while an old man cut his lawn with a scythe.

When next we saw Sarah, she was all dressed up, wearing a bright yellow shirt with large black flowers. We went to a small, unoccupied room with blank walls off the side of the common area. It was an austere room in which to meet such a gregarious woman. On one side stood a small uninhabited bed, on another, a small table and three chairs. Sarah sat down next to the window and started up again.

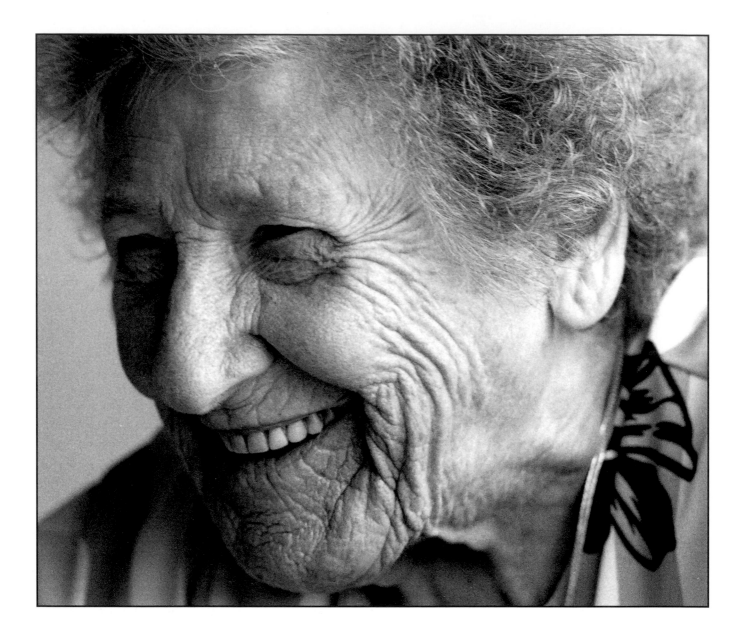

Sarah Benoit

I had five proposals of marriage but I never married. I never wanted it. I worked with a crowd of girls and I saw what they had to go through.

One said to me, "I'm tired of working and I'm going to get married."

I said, "Sure, that is the time you're going to work."

She got married and two months later she was pregnant. She still came to work but she was sick all the time. She took a month off to have the baby then she came back. She worked and then went home and looked after everything there. Sometimes she would be up with the baby until two or three in the morning and then be back to work at nine.

So I said to her one time, "How do you feel?"

And she said, "Sarah, what made you so damn wise?"

I did get engaged once but a few months before the wedding I asked myself, "Can I live with that person without ruining my own life and ruining his life?"

I thought about it for a long time and the answer was no. I suppose if all you had to do was take care of the kids and the home while the man went to work … but I saw many cases where the men stayed home and the women worked. Men had more power over women then. It's different now. Women have babysitters and they can go out. They have their clubs and their meetings. They have more freedom. It wasn't like that then. So I broke the engagement and that was it. We never kept in touch. When it's over, it's over.

No. I said I was never getting married. It was never the thing for me. I couldn't see myself living with one person all my life and I have never been sorry. I knew it would tie me down.

I was born on January 29, 1892, in Flat Bay, Bay St. George, about ten miles away from Barachois Brook. There were fourteen of us all together, but most of the older ones were married and moved on before the young ones came up. We had a big, old-fashioned house. On the first floor, we had a tiny kitchen – that is where we mostly lived – and a small living room. And there were four bedrooms with two beds to a room. The upstairs was one big room. That was where our parents were with the babies. The smaller ones were in cribs and my parents always had them near so they could hear them crying.

I had to do everything home. I had to do the housework and go and make hay. Of course, everybody had a small farm where they grew their own vegetables. And anyone who had boats and nets, that's what they did. Sometimes, I had to go cook for the men when they were out fishing. I started doing all that real young. Everyone did their share.

First it was herring. That was in May. We would go down and help pack the fish into barrels. After that, there was the mowing of the hay and work on the farm. Then the men went out on the banks for the cod fishing and then that had to be washed and dried. In the fall, they would take all the fish and go to the vessel. The vessel would leave Sandy Point and go to Halifax. Some of the men would get on as crew hands and come back with the winter provisions – beans, pork, salt beef, tea, sugar, coffee, and clothing, like boots for the winter – whatever you would need. They would do the same thing every year.

In the fall, the men went into the country to cut down logs to make barrels. The small birch was for hoops and the smaller ones for staves. For this they had what they called the draw horser and the draw knife.

They also chopped all the wood for the winter. Sometimes they made a chopping spree. The men would gather from the community, go in the country, chop down the wood and drag it all out. Everything was done by hand.

When they got back, there would be a big supper waiting for them. People would come in with the violin and the bodhran and everyone would have a dance. Sometimes they played cards until two in the morning.

We went to school but we didn't have much schooling. We would have a teacher for six months, then she would go and it would be another six months before we got another one. That teacher would leave and it could be another year again. All we got were scraps. It was awful.

There would be a dance here or a party there. We went to them a couple of times a month. And in the summer we went berry picking. That was all the sport we had.

We walked from Flat Bay to St. George's, all of six miles, to go to mass. In the winter you could hardly make it. Sometimes they had a horse and a sleigh to get you there but it wouldn't be every Sunday due to storms and the hard winters. On Christmas Eve though, we would all get ready and go down to midnight mass. Afterward, we would crowd around at a relative's home. There would be so many that the rooms would be full and my cousin would have to make beds on the floor for everyone.

I saw Christ for the first time when I was living with my grandparents. I went to the Codroy Valley to live with them when I was twelve years old. They were born in the Madeleine Islands and came across the gulf in an open boat with my grandmother's brother Luke, who was crippled. He died just after they came. My grandmother was Portuguese, French and Irish and my grandfather was French. They were never true Newfoundlanders.

When Christ appeared to me he was a youth, about fifteen or sixteen years old, and he wore a dark grey habit. He was coming towards me and I was so afraid I hid behind my grandmother's old rocking chair. Then he went towards the door and I came out. I wasn't afraid anymore. When he went through the door he looked back and stared at me. Then he left the door wide open.

Another time I was sleeping on a davenport in my room and I heard something out my window. I looked and saw a face appear. Then I heard footsteps and saw Christ coming with his hand outstretched towards me. He was fully grown and dressed like the statues in church. He walked toward me step by step and when he got to the foot of the bed he just stared at me. I stared back. Then I woke up and it was all gone.

About two years later I had a dream. I went down three stone steps to a small lawn. There was a hedge separating the lawn from the path. When I looked up I saw Christ coming down the very same steps and I realized he was coming for me. I put my hand under the hedge as he walked down and I closed it around his ankles. When I woke up, my hands were clenched as if they were holding something.

That's the God's truth.

There was a joke about Catholics in one community. They had never seen a Roman Catholic and they had never seen a frog. After a heavy downpour one day, out came this great big frog hopping along and nobody knew what it was. The minister was away on his vacation so they made a little tent for the frog and then they called the minister home. When he arrived, he didn't know what it was either. He touched the frog with his cane and it leaped up towards him.

Then the minister said, "Run, my dear friends, it's a Roman Catholic!"

So that's the way it was in those days. If you were one religion, the other wouldn't look at you. I don't think Roman Catholics are different from anyone else but I believe this – I believe that no matter who or what you are, if you pray to the almighty God

with all your heart and soul in the only way you know how, God is going to hear you. I believe all religions will come together. There will only be one chapel. It's coming.

I stayed with my grandparents until I was sixteen. Then I went to Boston. I had to find something to do to earn my own living. I had two friends that worked in a shoe store so that is where I got a job.

If I had a customer, I would ask her to sit down and I would sit on the stool in front of her. I would put her foot in my metal foot measurer so I could find the length and width and tell her what size shoe she wore.

Then I would go to work to sell.

All the shoes were stacked in the wall and they were arranged by styles and sizes. Every time a customer wanted a shoe, I went to the wall to get it. And every time I put a shoe on her foot she looked at it in the mirror on the floor. Sometimes, the customer would just be browsing so I would only stay with her for about fifteen minutes. That was long enough if it didn't look like she was going to buy anything. Another sales person would come by who wasn't selling at the time and tell me I was wanted on the phone. Then she would take a turn tending to that customer. If the other sales person made that sale, I would get credit for turning the customer over.

When I made a sale I went to the wall and got the right size shoes. Say it was size four-and-a-half, that was pretty common, and I would give them to the girl who wrapped them. If you gave mis-mates you were fined fifty cents. I was only fined once in the whole time I was working there, but the manager came over and tore up the penalty slip because we were so busy. It was the only time I had ever made a mistake. It was a good system, a good place to work. I worked with a really great crowd.

I would go to work and then I would go home. I lived with women I worked with. I had my own room and shared the rest of the house. That was the way it was, you had your own room and that was it. It was better than living with strangers because if you did that you would never know who you were getting in with. It was only through work that you could find a suitable place to live. I lived like that the whole time I was there.

I worked for that shoe store until the company closed down. I was there about six years. Then I went to another shoe company and worked in their chain of stores. I worked in Boston, then I moved to Cambridge, and I worked in Salem before I finally came back to the island. I was fifty years old.

I always knew I had to come back. I always said it was part of my life that I had to go through. I just knew it. I went to my brother's home in the Codroy Valley for a visit and found out that his wife had died and he was raising two sons by himself. Believe me, they needed somebody looking after them. My brother had TB and he was in bed all that winter. He would get better, get up and get on with it, but after six months, he would be down with it again. You had to go to the Crossing to get an x-ray and every once in a while I would take him to do that but mainly I cared for him in his home. It wasn't like it is now. You had to go forever to find a doctor and there were no nurses in those days. Whatever nurses there were, were in the hospital in St. John's. This was long before Confederation.

Believe me, it wasn't good before Confederation. It was really, really bad. My goodness, they had nothing! Well it changed afterwards. Every family … the parents got money for every child, had something to look after them with. And they got something for themselves too. They had something to keep them going.

I voted for it. Some people were going to kill me for voting for it, but I said I knew what I was doing. I lived in other parts of the world and I knew what Canadians were living like. Some of them said the Canadians would come over here and take our farms.

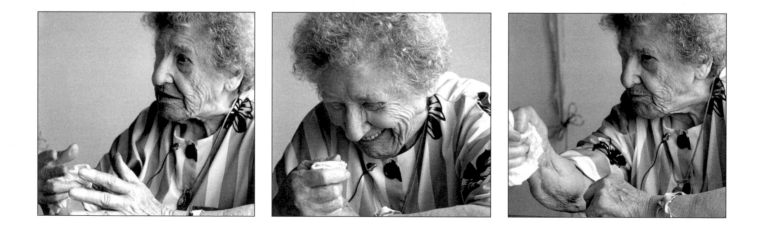

I told them, "Your farms over here wouldn't make a backyard to the farms they got over there. Why over there, they had thousands of acres! They had to make maps to find where their corn was planted!"

Yes, I voted for Confederation because I knew what I was doing.

I remember my brother coming in that morning and he said, "Well you got it, Sarah. It's gone over."

And I said, "Thank God, it's gone over."

I heard a man cursing Joey Smallwood. He said that Joey Smallwood was trouble.

A few years later, I heard the same man get up and say, "God bless you, Joey Smallwood."

If it wasn't for Joey Smallwood I don't know what would have happened. He was really interested. He knew what he was doing and I knew what he was doing. I was all for it.

Everything is better now. When I was a child, Newfoundland had nothing. There would be those who would come and fill their pockets with what Newfoundlanders had and then they would go.

I lived with my brother and stayed with his boys until they were through school and working. After that, there was nothing more for me to do. I went to Stephenville Crossing and I boarded in a boarding house until it was time to come in here. I had a hard time getting in at first because they said I was fit both physically and mentally, that I didn't belong in a home. After about six months I convinced them.

I'm in my ninety-eighth year now. I don't have too much longer, but it doesn't make any difference to me. I don't think much about growing older. I just think day to day. I get plenty to eat and I get along with everybody. I am able to get up and walk around. I can walk right around the building twice a day if I want to. I have a little bit of sense left. When the time comes I will go, but I'm not quite dead yet.

Sarah Benoit was born in 1892 and lived until 1995, when she died at the age of 103. She lived to be one of the oldest people in Newfoundland.

Hawkes Bay,
The Great Northern Peninsula

A S WE DROVE north on the Viking Trail out of the Long Range Mountains and deep fiords, the land flattened out. The coastline was barren and rocky and the few trees were stunted and bent by the constant wind. It felt primeval and desolate, like we were driving to the edge of the world.

A thin stretch of land went out to the sea, ending in a lighthouse. Alongside it were two old houses open to the elements. Their clapboard was weathered and grey, like their paint had been blown off. They looked tiny and vulnerable against the expanse of sky and sea.

Small communities sat along the highway and as we drove up the coast we passed billboards with religious messages. It was as if the farther north you went, the more faith was needed.

We passed the Daniel's Harbour zinc mine. It had closed that year, which was a huge blow to the surrounding communities. Many of the workers were beginning their exodus, hoping for opportunity elsewhere.

We drove into Hawkes Bay, a small community sheltered in a very deep harbour: the home of Rufus Guinchard, the famous Newfoundland fiddler. His name was everywhere. It was on the stage used for outdoor concerts and the annual folk festival. Rufus was the local celebrity. All his life he had played at everything from birthday parties to wakes. He was the main man for weddings and square dances. It was wonderful to think that perhaps all of the people we saw moving around there had

listened to his music, that, like us, they had been moved by it. Through his music, we all shared an intangible but strong human connection.

We ordered a coffee at the counter of an Irving station and asked the young waitress who served us if there was anyone there who would talk to us. She gave us Viola Payne's telephone number.

Viola's house was quite beautiful. It was solid and well built. Inside, everything was placed just so. She had plush cozy furniture and very green plants. Her husband was friendly and witty, and before he left us to our interview, he told us jokes that made us laugh.

Her two daughters ventured in and out, making comments here and there and teasing their mother about how tiny she was.

Viola was a wonderful contradiction. She was very open-minded. She read her Bible every night but never tried converting anyone. She believed firmly in the sanctity of marriage but spoke openly about women's rights, birth control, and breastfeeding. Viola was one of the first post-mistresses to work in Hawkes Bay.

We stayed at Torrent River, a beautiful park with wetlands and forest. It rained the whole time. When we weren't with Viola, we were at the Irving station drinking coffee and catching up in our journals, writing letters home and relaxing. It was a lazy time and it seemed like a mini-vacation.

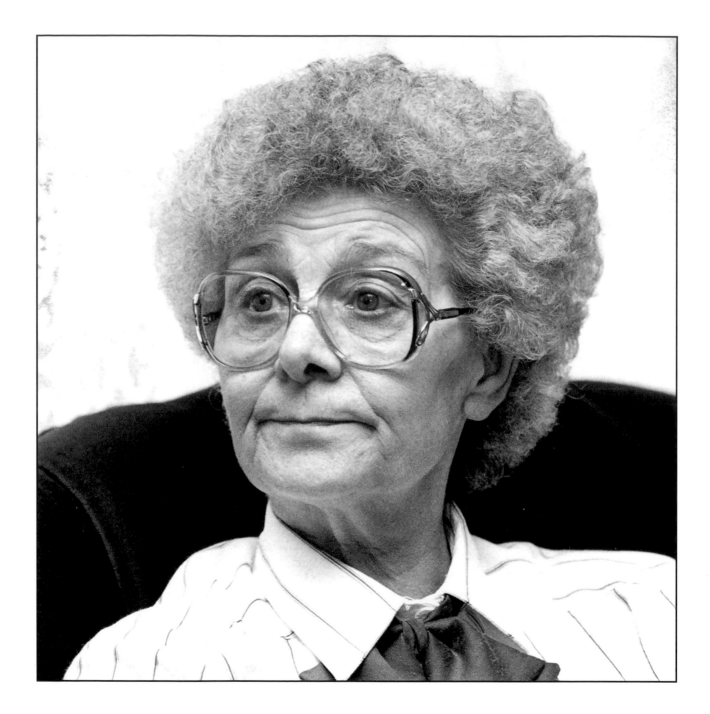

Viola Payne

I started work at the post office in 1959. I took it over from my sister when she became sick with tuberculosis. I was a housewife and a mother when I walked into that office, and there was no one there to tell me that this box belonged here or that box goes there. I was just married and we had only been in Hawkes Bay for one year. I never knew half of the people living here, and sorting it out was a nightmare. Everything I learned about the post office I learned by mistakes, and believe me, I made plenty. When the first inspector came in, I thought I was going to die, but he told me he'd iron everything out.

When my sister was at the post office, she went to work at four every morning and stayed until nine in the morning, so that is how I began doing it. At that time, there were only forty-five families living here. There were no roads and they would bring the mail in on horseback from Port Saunders. In the wintertime, if the weather was bad, the planes brought it in. Sometimes it was months before we got our mail.

I stayed at that first location for quite a few years. Then when my son built his house we brought his basement up to living standards and I ran the post office in there. Finally, I got permission from Canada Post, redid our basement and moved it over here, to our home. In my son's basement we had an oil furnace but the room was down in the ground. This one is on top and it's so warm; it's the most comfortable I've been since I began working.

I have worked for the post office for thirty-one years. We have 176 households living here now, about 600 people. We get our mail every day and it goes out every day too. Each day when I go in

the office I change the dates, get the printer ready, and do up the money orders, post all the mail, and get the deposit ready for the bank. I work forty hours a week, every day except Saturdays. On Saturday, I have a part-timer that comes in for four hours. I don't know how many more years I will be working, but this is definitely the best I've had it. It is a nice job.

I didn't do anything when I first got married. There was nothing to work at and besides, once a woman was married, it was a shame for her to go to work. It's not like today, if you see a woman *not* working you wonder what's wrong. A woman having to stay home and do housework is what makes men manipulate women. I think if the woman decides that she can look after the home and the family and go to work too, let her do so. Why not? A man couldn't support his family on his own today anyway. It takes both parents to work.

We were supposed to raise our babies and keep the home. That is what they thought we were there to do. I always said women were just machines to make babies. It's all they did. My mother had fifteen children. Around here now, if somebody has three, everyone is talking about what a big family they have. Do you think you would find anyone in Newfoundland now who has fifteen children? Never.

Back then, mothers didn't talk about anything. Everything was hush-hush. Talk about sex when we were growing up? Never heard it mentioned. Before my father died, they talked about having sex education in school. My father didn't know what to make of that. I never agreed with that either to tell you the truth.

However, if birth control was around in my day, I would have been all for it. I think women are wise not to have so many children. Take the way we lived, scrubbing clothes on a washboard and making bread. Now you have bread and roll mix. There are no flannel diapers. There is no getting up and washing babies' clothes every morning, scrubbing them on a board.

Do you think if birth control had been around in my mother's day, she would have had fifteen children? She may still be alive today if it was around. I believe she was fifty-one when she had her last baby. I was married when she had her last three. We were even pregnant together once. My mother had hers on the thirteenth of December and I had mine on the fifteenth of December. My mother's was a girl and mine was a boy and they grew up like brother and sister. Mom had two more after that. That was her entire life, having babies, and it was a full-time job, believe me. I don't know if it was nice after all.

Mom breastfed every one of her children too; I don't remember her ever giving a baby a bottle. They couldn't afford tinned milk back then.

I remember my father brought home tinned milk one time and we asked, "Daddy, what is that?"

"Milk," he answered and put two teaspoons in all our cups.

We always had cows and a lot of cow's milk in the summer but this was real milk. It was such a big deal. These days, it means nothing.

I breastfed all my children except the last two. I guess I got a little more modern like the rest of them and the bottle became the ideal thing. Just mix it up and stick it in their little mouths and that's all there was to it. Breastfeeding is another one of those things that just went out after awhile. If you see someone nursing a baby now, it's very unusual. It's all bottle-fed babies. But I prefer breast milk in the long run. I think it's better.

Every one of Mom's children except the last three was born by a midwife. Then the doctors came in. There were no doctors in the community before that. There was a nursing station down in Flower's Cove but there were no roads and it was a long way from us. There was a Doctor Curtis who came by boat some of the time but usually, anyone who got sick went to see Aunt Kate. She used many old remedies such as brown paper and vinegar.

Mom had such a hard time having her babies, she was never well and as soon as she had one, she was having another. She was with this one child and was real sick all the time. I was the oldest, and there was no such thing as getting someone to work for you so I had to wash and do whatever I could to help out. I worked in our gardens when I was very, very young, putting in potatoes. That was when I really started to work. I don't think I was any more than ten.

There was never a time when all my family lived together, but there was a time when there were sixteen, including my mother and my father, in one house. Three of my mother's children died really young, but my father had two of his brother's children living with us then. That made up for the ones that died. There were five rooms in the house; the place was crowded and you couldn't have a bed for everybody. There were probably four sisters in one bed. Everyone shared, you had to.

I was born in Brig Bay. It's a small place further down the Northern Peninsula. My father was a big worker but there wasn't much employment. Dollars were scarce.

When you worked, you got nothing for it. He was a fisherman for awhile. He would get up in the morning and go fishing real early. He would bring the fish in, split it and salt it and we would dry it. Every child who was old enough to lift a fish was out on the flakes spreading them in the morning, and later in the night was back there to pick them up. We would do it up in big piles and turn it all over.

When there was no price for fish, my father went to work at Bowater's in Corner Brook, but he was away from home so much that he decided to move his family to Daniel's Harbour and he went sawing lumber.

I had just finished school for that summer. I really wanted to go back in the fall but my father said I couldn't. He just couldn't support me anymore. I thought that was the hardest thing I ever had to go through. I went out and found a job at housework in Port Saunders. I couldn't have been more than fifteen.

I worked with my hands for four dollars a month. That was just one dollar a week but everyone thought that was wonderful. Then I got a chance to work for another woman and she paid me five dollars a month. I cleaned her whole house. I cleaned dishes, cleaned the kerosene lanterns and filled them up, and brought the water in from the well. There was no running water in them days.

It's amazing how you learn to appreciate things like water. We were living here in Hawkes Bay when there was the first running water of any kind and I was married for a long time before there was hot water. It was probably twenty-five years ago. I thought it was great, hot water from a tap. I couldn't believe it! We thought that

"There was never a time when my family lived together but there was a time when there were sixteen in one house."

was a blessing in disguise. Everyone wanted to know who was going to bathe first.

I worked at housework and then before I knew it, I was married. I was seventeen years old. I was twenty when I had my first baby and it wasn't long after that I had the twins. Then shortly after that, I had another baby and it was like I had two sets of twins. I had two cots in one room and two cots in another. Now that was something!

I had all my babies at home except for the twins. I have six children and all of them were born by a midwife. I think the doctors are all right, I would have been dead and buried only for the doctors, but if I were to have another baby, I would have it at home if I could. However, I'm not allowed. It's illegal now.

My husband was a logger. He worked seventeen and a half years with the Department of Highways. He worked for them as a labour man. Then he worked as a cook but he got sick and had several surgeries. He retired when he was only fifty-eight or fifty-nine. He is sixty-six now.

One of the most important things to me is that we have lived together as husband and wife for forty-six years. We disagreed a lot of the times of course. Who could live together for forty-six years and not disagree? But we agree a lot too. Whenever I say I think we should do something, he always does it with me. No matter what I say, he usually agrees. I remember when I bought this piece of land, I said we should build a house and he said we will. And we did.

I guess there could have been a lot of reasons for us both to run off, but when we got married there was no such thing as divorce. We will stay together until one of us dies. That is the difference with young people today and I don't think it should be. I would be very naïve to say that there shouldn't be divorce, but I don't agree with it. I know there are extreme cases when there are no other solutions, but if you divorce, I think you should stay as you are and not go with someone else.

I belong to the Pentecostal faith and it has been a real part of me. I was Anglican as a child, but when we moved here to Hawkes Bay, there was only Pentecostal Sunday school. I always went to church growing up so I continued as an adult. Only one of my children goes to church now. I guess there are some who stay with it and there are some who leave but I think the ones who leave it will be back.

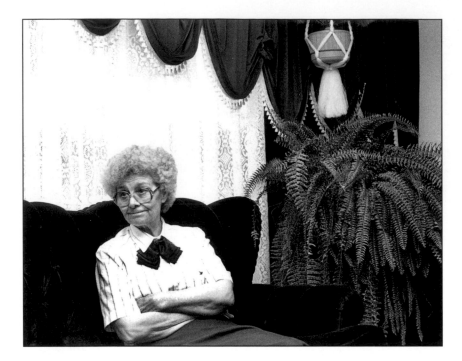

Religion has played a big role in my life. It has helped me through the hard times. Whatever problems come, it's helped me to face it and accept it. I've learned that you can't run from things, that you got to face them head on.

I understand that sometimes it is hard to believe in anything. This used to be a good, successful logging town. Hawkes Bay is mostly made up of people who came here for that. They had a mill set up here. Now the mill is gone and the mine is closing out in Daniel's Harbour. There is just no employment.

'Religion has helped me through the hard times. I've learned that you can't run from things, you got to face them head on."

I'm a town councillor and I've learned things about my community that I never ever knew and would never know unless I was on Council. There is one other woman councillor besides me and I believe the men appreciate us to a certain degree, but you might not find it as much in the outports as you do in the big towns. For example, I think in Toronto men and women are thought of as equal, also in St. John's maybe, but down here some say they do, but I wonder sometimes. Outports have a tendency to be a little bit behind but we do work very hard.

We've tried a lot of things. We tried to get the fish plant going but that didn't work and now some of the women from here have gone working at the fish plant in Port au Choix. There is nothing here. It is a hard situation.

I have seen a lot of changes, some good and some bad. Despite it all, I am glad I live here and I am glad I am a woman. I have found growing older hard; the morning I

turned fifty, I cried to break my heart, and I felt terrible when I reached sixty but I would still rather be a woman than a man. A man can't sew and a man can't knit. If I were a man I don't think I would ever do that and that's too bad.

Viola Payne still lives in Hawkes Bay. She continued working as a post-mistress until she retired at seventy-four, four years after her husband had died. It broke her heart to leave. The post office has since moved out of her basement and into a business area. When Viola goes to visit, they still say how much they miss her. "They were the best people in the world to work for." Viola is now eighty-two years old.

Pasadena

PASADENA IS A community of pristine houses and cottages. Located near the Humber Valley, it is "the crown of the Valley." There are flower gardens, sandy beaches, and beautiful woods trails. Unlike the bareness of the Northern Peninsula, everything here was lush and green. Soft as a pillow.

Sheilagh's grandmother lived here in a small white house tucked in between trees, surrounded by flowers and wild rose bushes. Phyllis O'Leary was known as Bobby to her family. Sheilagh's brother could not pronounce Nanny when he was young and said Bobby instead. The name stuck. "It suited her more than Nanny," Sheilagh said. Phyllis was known as 'Phyl' to her friends.

Phyllis was a small woman with large features and a deep and articulate voice. She spent most of her life in nature, skiing, camping and fishing. She was a lover of animals, who were her life-long companions.

"She was a real Saint Francis of Assisi. Every stray animal that came along, she took in. There are stories of her and her daughter picking up bees from the bushes and lining them up on their arms," said Sheilagh.

Unlike many of the women in this book, Phyllis came from a family of socialites. Her father was an opera singer and her mother threw fabulous parties. They were among the people who started the *Christmas Seal*, the medical boat that went around Newfoundland during the 1930s and was instrumental in saving many lives.

Phyllis enjoyed herself but was never much interested in large parties and entertaining, preferring a bonfire on the beach with friends instead. She had simple pleasures. Phyllis was straight up.

"There was no fuss to her whatsoever," said Sheilagh. "She was a real tomboy. But when she dressed up for a night out she reminded me of the Betty Davis type. When she was younger, she bleached her hair white blond, put on black eyeliner and real red lipstick. She was one of those tough broads from that era," Sheilagh remembers.

Bobby invited us into the home she shared with her pet budgie Herbie. He followed her everywhere. He was always on her hands or perched on her shoulder. While we were there she taught me to crochet.

It was the end of the summer, but the evenings were still very warm and humid. We sat out on her small front porch and watched the most fantastic lightning storm. The three of us sat in silence, listening to the rain falling on the grass and through the leaves of the trees while we waited for the bursts of thunder. The only other noise was the clinking of our ice cubes when we lifted our cocktails.

Phyllis lived in a small white house tucked in between trees, surrounded by flowers and wild rose bushes.

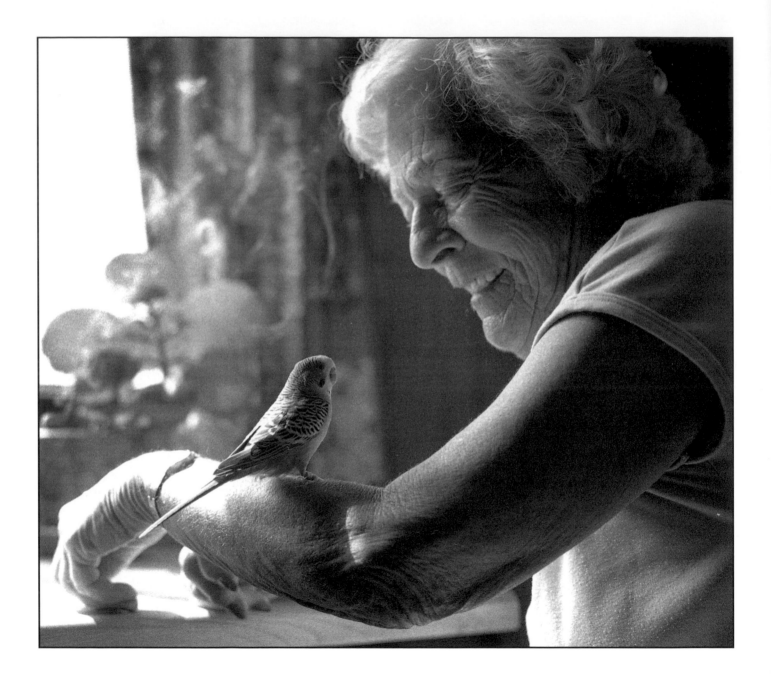

Phyllis O'Leary

I was born in Boston and moved to Newfoundland when I was four years old. We lived in St. John's with my father's father when we first moved here. My grandfather was a Trapnell; he was one of the people that started the *Christmas Seal*. It was the ship that travelled to all the communities with doctors, before the communities had doctors of their own. He had a house on Waterford Bridge Road. A great big beautiful house with a tennis court in the backyard. I will never forget it.

We moved from there to Power Street on the west end of St. John's. There was five of us: my parents, me, my brother Bus and my sister Ruth. I am the eldest. Ruth is a year younger than me but she looks ten years older. Bus is three years younger. His birthday is on the fourth of July. Ruth and I never got along. We never played together.

Ruth was a society lady. She loved entertaining. I was a real tomboy and a jack-of-all-trades. I could build anything. I've always loved carpentry. One summer, I built doghouses and sold them. I like all men's work, horseback riding and tearing around.

As a kid, I used to go for a hike and I would build tree houses. I cut trees and weaved them together. It was like I had my own little cottage. There was a pond we called Kite's Pond that dried up in the summer. It was all mud in the bottom and it dried into cakes. I used to take the cakes and build mud houses. I built them up like igloos. I made tables out of the mud for the inside and I made twig benches.

Tomboy, that was me.

My mother's name was Rose Isadora. Her father's name was John Green and he came here from England. Mom was from St. John's. She was a lady of leisure. She lived the life of Riley. We always had enough money to keep maids. My mother never did a bit of housework in her life. It wasn't until her latter years when she stopped having maids that Mom started cooking.

My father spent his life doing odd jobs. When we were living in Boston, he worked as an optometrist. What he really wanted to be was an opera singer but his father wouldn't let him. He had a fantastic voice and he performed in most of the concerts, singing for anything that went on in Corner Brook.

We moved to Corner Brook in 1925. Dad got a job at the mill. Growing up in Corner Brook was great; I loved it. I went to the only school that was there; everybody went there, all religions. It only had four rooms, two upstairs and two down. I guess it wasn't very big but it looked big to me back then. It was grade six and seven in one room, eight and nine in one, and ten and eleven in another. That old school is torn down now. It's in the ground.

"My mother's name was Rose Isadora. She was a lady of leisure. She lived the life of Riley."

I was still going to school when I met my husband Stan. I was madly in love with him and I couldn't wait to get out of school in the afternoon for him to call. I dated a couple of boys before him, just going out for a movie or an ice cream, but Stan was the only real boyfriend I ever had.

I liked older men and I was sixteen when I married him. He was twenty-eight. He began working at Bowater's and we took over the company house for twelve dollars a month. That was for the first two years. It went up to sixteen dollars after that, then twenty-six dollars and then we bought it.

When I first got married, the only thing I knew to do was boil the kettle. All I made Stan to eat was bacon and eggs or ham and eggs. Then I learned to make date crumbles and that was all he ate for about a year. He loved chocolate cake so I learned how to make a chocolate cake too.

But it went on so long he finally said, "Phyl, for the name of God, learn how to cook something else, will you, I'm sick of chocolate cake."

I finally got the hang of it.

I had two children, a boy and a girl. Both were born in the hospital; one was an easy birth and one wasn't. I tried to breastfeed but it didn't work so I had to use the bottle. It was a year after I was married that I had my first child. I didn't mind having a child that soon, I was ready for it and he was real sweet. Sean was born in 1929.

He didn't keep us from moving around; I dragged him everywhere I went. I took him out skiing and he would be down in the field playing baseball every summer. In the wintertime he played hockey. I loved watching him. I never missed a game.

My son was a dispatcher during the war. He went on his bicycle delivering messages. He was always on his bike. I remember when there was a fire at the school, Sean got his bike out, I got on the crossbars and we drove down to see it. I was frightened half to death. Another time, the Glynmill was on fire, half the building burned down. He took me on his bike to see that too.

Twenty-one years after I had my son I had my other child, Deirdre. She was a beautiful baby. Sean was away then; he didn't see her until she was two years old. My husband wasn't with me either; he was away a lot of the time working. Stan never saw her until three weeks later.

I was thirty-nine when I had her but nobody thought it was unusual to have a baby that old. And my husband didn't make much of it either, he didn't go overboard about anything. He always reacted to life on an even keel.

We had an easy life. I've never had to work very much. We liked to have parties and bonfires and sing-a-longs. I used to play the ukulele, but I was just an amateur. I played a saxophone for awhile and the violin and the piano. I could never play guitar, I could never get my hands moving right. Deirdre and I used to play tin whistles, we'd play duets together. We had a ball.

It's been thirty years since Stan died. When he first got sick, we thought it was just the flu but it was cancer. He was born on December 3, and he would be ninety this year. I didn't feel anything at first. When we were married, Stan went to Port aux Basques for the winter. Bowater's shipped their paper over there and then the bay would freeze over. He was gone all winter, every winter. It was the sixteenth of January when he died and it was like he was in Port aux Basques. I expected to see him at anytime. Then I got used to it.

He was away in the summertimes too. He was always gone somewhere with a baseball team. Or Bowater's would send him to Florida on business, or to England. He was over to England four times. So you know I couldn't miss him really; I was always alone anyhow. If he had been home all the time, I would have missed him more. But we had a good life. As far as I'm concerned it was good.

After he died, I worked with the Imperial Optical Company for five years. I saved my money and moved here to Pasadena. I also had money left from when I sold my house in Corner Brook.

It was 1967 when we moved here. It was seven years after Stan died. There were woods all around us and the house was just a cabin. We built the addition on after; we put in an extra room and a basement. Most of the time it was just me and my daughter; my son was away a lot then but I never had a problem raising her alone. It was nice.

We always had a lot of animals. We had a dog all our lives. We had a Chihuahua and then a Great Dane. He was seven feet tall standing up. What a size of a dog. I had a cocker spaniel, Skipper. I had a bulldog. I had three German shepherds at different times, and two Newfoundland dogs. We always had cats by the millions. We had four cats once that all died of cat fever. We had to put them down; it was the saddest thing.

The last dog we had was named Bunny. Bunny was a mongrel but he looked like a Lhasa Apso. He was gorgeous, just as good as any purebred dog. He was right woolly; he had beautiful fluffy hair, and was he ever smart. One time, I wrapped up one of those big, chewy bones for him for Christmas. He walked over to the Christmas tree, sniffed around everything and picked up his present.

Then he came over and laid it down in front of me and looked up.

I said, "Yes, that's yours, you can open it."

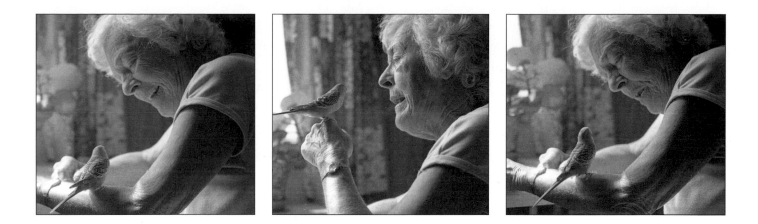

And he opened it. Honest to God, he picked it out of all the presents that were there.

Bunny eventually got cancer. It was so sad when he died. He was the smartest thing; I swear the darn dog nearly talked. He was sweet. What a dog!

I don't have a dog now. I couldn't afford it if they got sick, and I'm not going to let the poor animal suffer because I can't bring him to the vet. So I got this little fella, Herbie the budgie. He spends all his time on me. When I'm in the sink he tries to bathe in the cups. He's always sitting on my hand picking at the needle when I'm trying to crochet. He never stays off me.

When we first came here, we had parties all the time; we would all go down to the beach, I would play the uke and everybody would sing. We did that for years. Now I don't see any of them. Some of them I forget, it's so long since I've seen them.

I don't like cities. There's lots to do in them but it all costs money. I don't like to go out to eat and I couldn't be bothered going to a club for a drink. I would rather have a bottle at home. I always made my own wine.

I remember one time I made wine by accident. I love the taste of raspberries, raspberry jam is my favourite and I had just bought a gallon of them to make my jam. I put these raspberries in a bowl, put them on the shelf in the back porch and forgot all about them. I went out weeks later and

they were all gone to mush. I didn't want to throw them out so I scraped them all together, put some sugar on them, put a bit of yeast in there and I left them to ferment.

Then one day I went out with an empty rum bottle, filled it up with the juice, sealed it and left it for about a year. I had forgotten all about it until Mrs. Collins came over. She was an older lady, much older than me anyway, and she came to visit every time I made a marble cake. I always asked her over for a piece and a cup of tea. This one day, there was something I had to get off the top shelf and I spotted the bottle. I told her what I did and asked her if she would like to taste it.

"Oh Gert," I said. Gert was her first name. "How about some of my raspberry wine?"

"Yes," she said.

Well she went home on her two ears. Was she ever loaded! It was so good we drank the whole bottle. Oh God, I was so woozy but it tasted just like the raspberries. It was beautiful. The nicest wine I have ever had.

Myself and my friends, Floss and Mona, are the only old ones here now. There is another couple just moved in but I don't know how old they are. I haven't met them yet; they only moved in a month ago.

This used to be a place for summer cottages but now there are homes all year around. You see people walking all the time. They are always walking, husbands and wives strolling together. There is one couple who I have to laugh at, they walk like two soldiers.

During the day, I usually sit here by myself. If Blanche comes out, I will talk to her. If she doesn't, I'm still here. I might walk down to the end of the street and see Marion for a coffee but by the time I get back I have to sit down. I have emphysema now you see.

There is a clinic at the drugstore and the doctor comes from Corner Brook and sets up there in the afternoons. I go see him but I don't know if I trust him or not. It seems to me that the doctors don't know what they are doing half of the time.

In the wintertime, I go to bingo. That's all I do. In between games we might play a game of scat. If I didn't go there, I would go nuts, I think. I see everybody up there. The same crowd has gone every night for years. I know everybody at the hall. It's great to go to bingo.

I'm seventy-nine now, I got a lot of years left. I've been living alone for thirty years and I don't mind it. There is nobody cluttering up the place all the time. Sometimes I get lonely but I would rather live by myself. I love to have company but I wouldn't want anyone living with me now. I like living alone.

If I ever decided to live anywhere else, I would like to go to British Columbia, to the island. My son went once. They took the crib and filled the car and were back nine days later. It rained too much. I think it was April when he went over.

It is gorgeous in B.C. Some say the trees are different, but trees are trees, you know what I mean? It's the same as here as far as I'm concerned; it has hills and valleys and ponds, everything you like. It's beautiful.

I was there for two months one time. Deirdre and I went in 1966. I remember we went water-skiing. I had never been water-skiing before but I'll always try anything once. Well, I skied all over the ocean, and when they slowed the motor down, I let go of the rope and skied right into the beach like I had always been doing it. You wouldn't know but I was on them all my life.

Phyllis O'Leary was born in Boston, Massachusetts, in 1911. She was raised in Corner Brook and spent most of her life on the west coast of Newfoundland. She was an animal lover and avid outdoors woman. Phyllis passed away in 1994.

The South Coast

THE SECOND PART of our trip was made in the summer of 1991. The cod moratorium would not be formally announced for another year, but there were dwindling harvests, and many fish plants across the province were already shut down. The day before we left for the South Coast, Sheilagh and I walked the length of the St. John's harbour. It was empty. The fishery was in freefall.

We left St. John's at 4 a.m. and drove along the vacant highway with the summer sun rising behind us. We were going to Terranceville, a small fishing community at the head of Fortune Bay to meet the ferry for Ramea.

When we'd embarked on the coastal boat to Ramea, it was blowing a gale. From our steadfast position on deck we observed whales breaching in the distance. As the ferry sailed into narrow fiords, the winds would calm and the water would turn to glass. Inside, small communities of twenty or thirty houses built in a circle clung to the shore. Behind them high cliffs rose up from the land. Whole communities came out to greet the ferry, a daily ritual. Parcels and crates were loaded and unloaded. Then we were off again.

Soon the boat began to roll around in huge swells and I got violently seasick. Hanging over the deck and retching into a small bag, I begged the captain to stop.

He laughed and said, "Not long now."

After what seemed like an eternity, we finally arrived in Ramea. We checked into the Four Winds Bed and Breakfast, a very large house with a tremendous amount of land and a white picket fence encircling it. The Four Winds was once home to the Pennys, a wealthy merchant family, and the

walls were covered with their family portraits. There were paintings of the *Pennyson*, the boat christened after the matriarch Marie Penny. Beneath the name was written, "Queen of the fishing fleets."

The woman who ran the B&B said it was always rough just before Ramea. Two different currents converge there and create swells, sometimes capsizing small boats. Still reeling, I went up to my room and slept, thankful to have made it back on land.

The next morning Sheilagh and I stepped out on the verandah and the heavily salted air mixed with the perfume of roses. From the view on top of the hill we could see the whole island through a dense fog. Every now and then the sun burnt through, and for a few moments we could see the houses dotting the coast of the island. The place was full of idle fishing boats and out-of-work fishermen sitting around on wharves and benches.

The island of Ramea, isolated in its fogbank, felt a million miles away from the modern world. We could have been on another planet where time moved in a different

Sheilagh and Rhonda in Ramea

dimension. As outsiders we felt very exposed and had difficulty connecting with the people living there. The fish plant had just closed and this was the beginning of their fishing crisis. They were not open toward us. Perhaps they didn't want strangers to witness their vulnerability or their grief. Who could blame them?

The town hall clerk gave us a copy of an old photograph.

"What Ramea used to be," he said.

There were dozens and dozens of fish flakes stretched around the whole of the harbour. So many fish. And there were all the women in their full skirts and petticoats, long boots up to their knees, bent over and turning them. The three women we spoke with all grew up in this fishery, and for sure, their mothers or grandmothers were probably in this photograph.

Beatrice Sibley was sweet and shy and spoke in such a soft, low whisper we could barely hear her.

"Family is the most important thing," she said.

"If people don't fight, resettlement will probably happen again."

All the hard work Beatrice did throughout her life she considered inconsequential. She raised five children by herself and was proud of every one of them. Her husband was a fisherman and was gone ten months of the year.

We took a day trip to Burgeo to meet Annie Dollimount. While she finished cleaning up the dinner she had just cooked for her boarders, we waited at the sandbanks, a beautiful two-mile stretch of white sand that shouldered up to the sea. We dipped our feet and faces into the icy waters.

Annie was hesitant but agreed to tell her story. Like Beatrice, her husband was away ten months of the year fishing and she raised their family alone. She said the younger generations didn't understand the nature of freedom inside of commitment.

"When I got married," she said, "it was for life."

Back in Ramea, we met Vivian and her husband Arthur Cluett. They lived together in a 150-year-old house. Vivian spoke with urgency when we met with her. She felt fear for everyone living there. She compared it to the hardships of the 1930s, yet she hoped the government would not abandon them. It is heartbreaking to know now that they did. Their fish plant never did re-open and many had no choice but to move away. Their tiny island, their home away from everywhere, never truly recovered. It is as if they were just set adrift.

A man we met said that they all knew this was coming. No one needed scientists to explain the problems with our fish stocks. Mismanagement was what it came down to, and a lack of common sense.

"The government opened the fishing season at the same time the female fish laid their eggs," he said.

The fishermen were aware of this. They were outspoken about it, but no one listened. There was no choice. Nothing had a chance.

It was as if we were leaving a place that existed now only in our imaginations.

Our return journey home was made in silence. Soft, deep layers of fog enveloped us. There wasn't a breath of wind as mute porpoises rode the bow wash and led us away from that tiny island. It was as if we were leaving a place that existed now only in our imaginations. A whole coastline of heartbreak and misplaced hope, whose way of life might soon vanish like the fog banks that swirled about it.

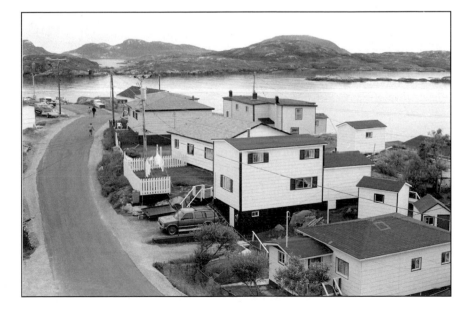

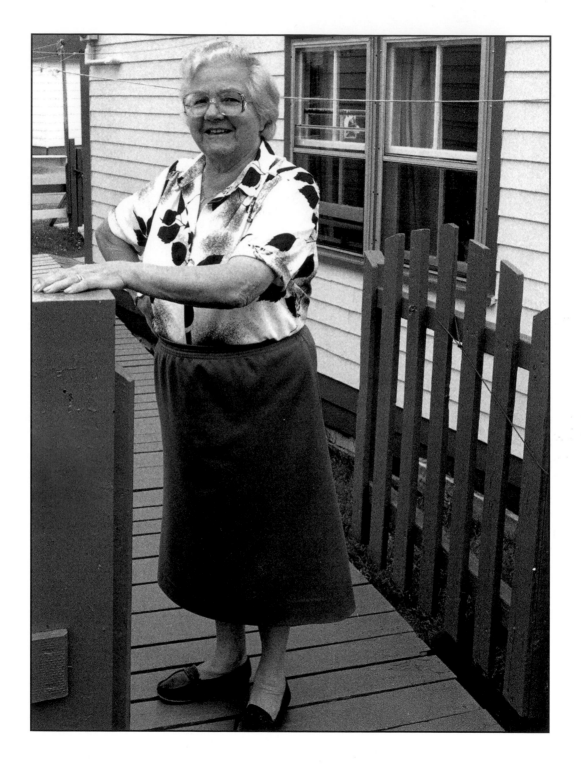

Beatrice Sibley

I grew up in Isle aux Morts. It was a little island off the South Coast. I was born there July 17, 1917. There is nothing there now.

When we first moved to Ramea, we were part of the resettlement program. We took our home with us. There were only three or four other houses around here at first. Gradually people started coming in from communities all around.

My mother had seven children, four boys and three girls. She spent her life raising us. That was pretty much all she could do. Women didn't mind having babies then, or at least it didn't seem they did. I don't know if people would have taken birth control if it had been available. My mother had her babies and she breastfed them all. She only had one child on the bottle. Mom was married when she was twenty. That was old for a woman back then.

When we were younger we all had to sleep together. There were seven children, and my mother and my father, and we only had three bedrooms. We didn't mind it. You didn't know the difference back then.

We went to church every Sunday. I don't go every Sunday now because I can't get there. I do the best that I can do.

We picked a lot of berries; there was always bakeapples and blackberries. That is what we did for fun.

People didn't go to school for very long. I went until grade six. I was lucky to get that far. I was thirteen when I left. I came out of school to look after the house for my mother after she had her last baby. I washed the floors and all the rest of it.

Young people are different now. I don't know if they are doing right or wrong. We started working real early. They don't work at all. The pre-teens and teens have their dances. All the girls have boyfriends. It seems to be encouraged. We never had that stuff. When we were ten or eleven, we were never allowed outdoors. I lived with my mother until I was married.

My husband was a fisherman but he left that after awhile. When the fish started to go downhill, he came to work ashore. He was a jack-of-all-trades. He worked in a lot of places. The last place he worked was the machine shop. He worked there until he got sick. Now he is retired.

When my husband was fishing, he was away a lot. That was his job. He had to do it. Sometimes I got together with other women when our husbands were out on the water, but for the most part, I never worried too much. I had my children.

I have five children, eleven grandchildren and one great-grandchild. Only one of my children, one of my sons, lives here now. He is an engineer on the ferry. All the others live away.

The only thing I ever did was raise my children and do my housework but that was work enough, believe me. I breastfed all my children. I think it's healthier. That seems to be coming back again.

I had a midwife for two of my babies. Then the doctors came and midwives were only used for emergency but I wouldn't say the doctors did a better job.

It's not as isolated here now. There is not as much superstition. There was a time when people said they saw someone as a ghost two or three weeks before they died. I think they made it up half the time, but sometimes it did happen. You don't hear things like that anymore.

If you had to go to the doctor back then, you had to go to Corner Brook and you could only get there by boat. Even when the hospital was built in Burgeo, you could get x-rays or blood tests there, but you still had to go to Corner Brook for some things. You had to go there if something was serious.

I have never had any serious illnesses, thank God! I have been lucky. I only have a bit of arthritis in my hands. That's my only problem. I have never had an operation and I have never been put to sleep. I have only been in the hospital once and that was for my knee. I broke the cartilage in it one time when I fell down.

We have two doctors living in Ramea now. If you went into labour, they would be the ones to take care of you. We have a public health nurse who comes to visit now and then and a dentist that comes once a month. We still rely on our friends and family for a lot of things.

There isn't much fish here now. People still go out and get what they can but the fish plant is closed down. The one in Burgeo isn't open any more either. There are a lot of people moving away. More go every year.

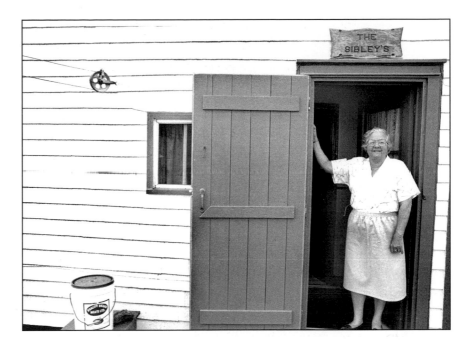

I am the only one of my family left living in Newfoundland. The rest of them went to find work when they were younger. I have a sister in Halifax, another in Kamloops, B.C., and two brothers in Ontario.

We've been to Halifax three or four times. We've been to St. John's a few times too. My husband and I nearly moved to Halifax once, but at the last minute we decided against it. I think there are definite advantages to living in the city. Things are more comfortable. There are more places to go but I like living in Ramea. Sometimes, I get lonely but the television keeps me company. I watch the stories and stuff. I don't know what I would do without the television.

"I have five children, eleven grandchildren and one great-grandchild."

Beatrice Sibley was born in 1917 and passed away in 2004 when she was eighty-seven years old.

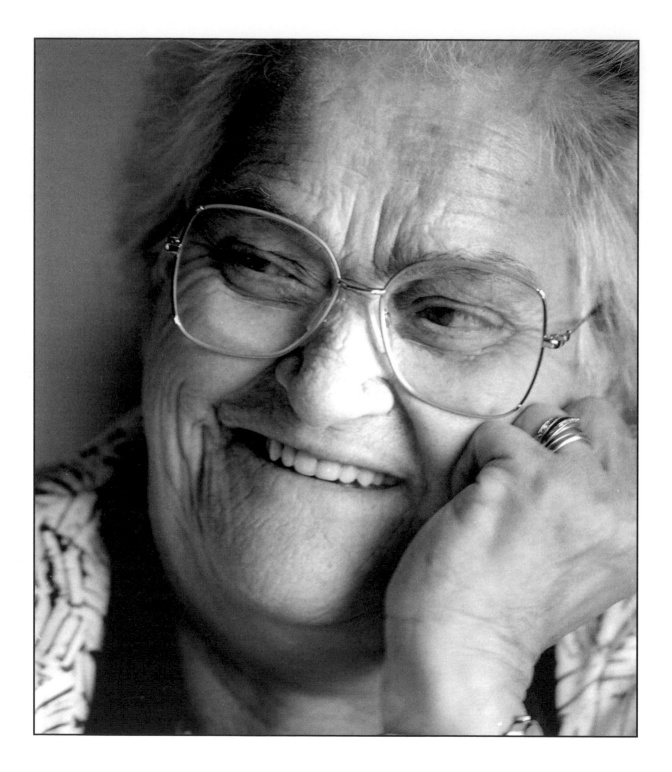

Annie Dollimount

I was born in Coppett. It was this little island just past Burgeo that you could only get to by boat. There were a nice few families living there at one time, ten or thirteen houses full. It wasn't real big but it was cozy. On Sunday mornings everyone would get together to sing a few hymns. We had no church so the whole community would meet at the school. It was only one small room, but there were only ever fourteen or fifteen kids going to it so it didn't need to be big. Once a month, the minister came by on boat to see us and have a proper service.

You had to have a boat or you would never get anywhere and if the weather was bad, you'd be trapped. My father's boat was about as big as a daybed with no engine onto it. I always went with him to catch a few fish and some lobsters. Dad always made good lobster pots. What we caught together we ate, it was never to sell. We always had a nice meal of lobsters.

Everyone fished and every morning we had all this fish to put out. We'd be out on the flakes spinning it, turning it three or four times a day, until it was ready to sell. A big boat would come in and we would carry the fish down to her and pack it up. I don't know where it went after that, I couldn't tell you, but I know we didn't get much for it.

We kept the old cods' heads and the stomach of the fish to take up to our gardens. We used it for manure for our cabbage and potatoes and turnip. If it wasn't winter, we began our day in the garden and then we would do our housework. We had a two-storey house, with the sisters sleeping together in one room and the brothers sleeping in another. We had no canvas; it was nothing but the bare floor

and no scrub brush so we tied boughs together to clean it with. When we scrubbed upstairs, we'd have to dry the ceilings downstairs because it would all come through. We'd always have to hurry so the beams didn't get too wet.

I had twelve brothers and sisters. I'm the oldest. I was nine years old when I had my first little sister. They told me there was a little bird that made her the night before and put her arms somewhere. I guess they said that because she was wrapped in a blanket and we couldn't see her limbs. We didn't know where babies came from. No, my God, they wouldn't tell you nothing about that. It's strange, hey, how they learn about it in school now. I'm all for it. I only got my grade six when I was going to school but that's all most got then.

I started making bread when I was ten years old and I could bake a batch of bread as high as I can make right now. Although, the first time I tried, I got my hands into it and I couldn't get them out. My mom told me not to use so much water and eventually I got used to it. I'd make a big pan of bread in the mornings, shove in down the back of the oven and go on about my business until it was done.

In July, we sawed up our wood. The men would go down to the bay to cut logs and bring them up to us women – well, we were only girls then – and we cut it into smaller pieces. It was the hardest kind of work. We'd cut enough for the whole winter. Everywhere you looked it was wood, sawed up and packed in, down roads and around houses.

We kept sheep for wool and would do up about four fleeces a year from them. We skinned it, carded it, twisted it and washed it out. Not a bit like now. Well, I wouldn't do it now anyway. The younger ones can't believe it, all the work we did.

There wasn't much to do for fun until Christmas. We'd hang our stockings like they do now. We'd get half an apple, two little candies, a sweet bun, a pair of mitts or a pair of socks. We were a big family and our parents had to spread everything evenly but we didn't care. We thought it was a big treat. We were crazy over all that! Not like now, there's no Christmas now. It's only a money racket to put you in debt. I pity the younger ones. If my poor old father could come down on this earth – not my mother, she's not dead all that long, but my father – he wouldn't recognize anything. He wouldn't know what to do with a TV, poor old soul.

But all that was a long time ago. There is nothing there now. Coppett was resettled years ago. Some went to François; others went to Port aux Basques and others came here to Burgeo.

I went to François when I was fifteen. I went down on a skiff. There was a crowd going down and they asked me if I would like to go with them. They said they would have me back home again in a week or so.

I told Mum I was going and she said, "What are you going down there for?"

I said, "I'm going. Perhaps I'll be back, perhaps I won't."

I never went back.

There were people calling after me for housekeeping. I got five dollars a month for it. You'd pay two dollars for a pair of shoes and I bought one pair of shoes a year. Boats came into the harbour with little shops on board, that's how we got the things we needed. I never knew where these boats were coming from but I know they did get some of their stuff from St. Pierre. The shoes we bought were from there. You didn't have to smuggle them. You'd often smuggle liquor but you never had to smuggle shoes.

I got married when I was seventeen. Everyone married at that age. That's just how it was then, you met and you got married. You wore a plain dress and a pair of shoes, and those who didn't have shoes went barefoot. Now it's changed completely. It costs hundreds and hundreds of dollars to get married. Sure, the dress costs a thousand. Then they're only together for a few years before they leave each other. Who would want to get married with all that going on? It's too much. When we were married it was simple and there was nothing to tear you apart, only sickness.

My husband was a fisherman, he was chief engineer. He was paid five dollars a day and his second got three. He was always out on the boats. He didn't know what his family was hardly, he was out so much. When the bad weather came it was really hard. It was frightening knowing your husband was out in a storm trying to get in. We would phone each other, the captain's wife and I, and we'd talk each other through it. Sometimes, we'd get together when the children were asleep. We did a lot of knitting and played a lot of cards. We lost a lot of sleep those nights. When they finally did get into land, they would unload the fish and be gone again. That was what it was

like. My husband was probably home two months out of twelve. He hardly saw his own children but that was nothing unusual; all the women raised their families then.

I was too busy to be lonely. I had to take care of my children and maintain the house. It was two storeys with no furnace and did it ever get cold. In the winter you couldn't see through the windows for the frost that would flower up all over the glass. We'd come down over the stairs in the morning and everything would be froze up. All the water I brought from the well would be frozen in buckets all over the floor. Even the bread would be froze and I would have to put it in the stove to thaw before I could make toast for breakfast.

When I was pregnant, the smell of toast on the stove, did it ever make me sick. If my husband was home, I'd stay upstairs while he made toast for the children, it made me so sick. I can smell it now, isn't that something?

I had a real tough time carrying all my children, four months straight, boys and girls alike. I was sick all the time. I'd be so big and there would be so much work to do. I was always washing diapers. There was no such thing as pampers; our diapers had to be washed by hand with the washboard and tub. I'd be bent over the tub really pregnant, and I would always get sick.

I had my first child when I was eighteen and I was with a midwife for all my children except the last one. She had to be born with a doctor. I was thirty-five when I had her and I had a really hard time. All my children were born at home.

It was not like it is today; now the women go to Corner Brook and have their babies and come back; that's all there is to it. In them days, there was no such thing as Corner Brook. Well, Corner Brook was there but it might as well have not been; we couldn't get to it unless we went out in a boat or flew on a plane.

I was a midwife myself for a little bit. I borned four babies, two in François and two in Burgeo.

The first time I did it, her husband came out and said, "Annie, can you come down, because Louise is having a baby and the doctor is in an operation?"

When I went down the old lady next door was kicking up such a fuss. I calmed her and said I would do what I could. I delivered that baby and it was a girl. I cut the cord real long from the belly

button because I was so scared; I didn't want the baby to bleed to death. After I borned her I didn't know if I had all the afterbirth out. I asked the woman from next door if she could find a tray or something that I could put it on for the doctor to see later, to make sure I got it all.

I was back to my house when the doctor finally did come; I could see him coming over the road through my window.

When he went in their house he said, "Who did the job?"

They told him and he told the old lady to come and get me.

"My father's boat was about as big as a daybed with no engine onto it."

I was real young, I only had three of my children then, and I was scared to death that I did something wrong.

I walked down to the house with the old lady and when I went in through the door the doctor said, "You're going to tie this belly button."

I said, "I don't mind tying it where you are to."

I was comfortable to do it with him there. He gave me this little piece of stiff stuff to help tie it with and I did it. Then he gave me the clamp to clip off the rest of the cord because, like I told you, I had left it that long, I was so scared. I finished that and he said I did a good job.

The doctor then asked me if I would go midwife. He said he would send me into St. John's for a six-week course and I wouldn't have to pay. In fact, I was having a baby myself at the time but he said that it wouldn't matter. I told the doctor I would have to wait until my husband came home to ask him about it.

Well, my husband wouldn't hear of it. "That's what you're not!" he said. "You got your own family and if you were a midwife, you'd always be gone. You'd always be called out somewhere."

So I didn't make it out because my husband wouldn't let me. But I think he was right; if I did take it up, I'd always be on the go. I wouldn't have had time for my family.

I only have one son living here now; most of my children live away. I have two sons in Toronto, a daughter in Edmonton and I got a son and a daughter in Corner Brook. They're all over the place but I call them often. We are a close family

My husband has been dead fourteen years. He wasn't quite sixty. He had a tumour on the brain. I took him to the hospital twice, and the second time they operated but they said it was too close to the brain, they couldn't get it. He came home then, my dear, and he died. We had a beautiful, lovely, wonderful old life together when he was home. Like I said, he wasn't home that much. When you're on the sea, you know what that's like, it's really hard.

You would be surprised how many widowed women there are here now. There are more women widowed here than men, that's for sure. We get together now and again and play a couple of games of cards. We play 120s at the parish hall. We have sales; we do crocheting and knitting at Easter time

and in the fall to raise a bit of money for the church. And the Lions Club has a supper for us the last day of Christmas. It's mostly women that go to it. You would be so surprised.

I remember asking my sister-in-law one time about growing older.

I said, "What's it like?"

She said, "You don't notice it. You're getting older but you're just the same as you ever were."

You feel it if you are sick or something, but other than that, there is really no difference. Life just goes on.

Annie Dollimount was born in 1920 and passed away in the early years of this century.

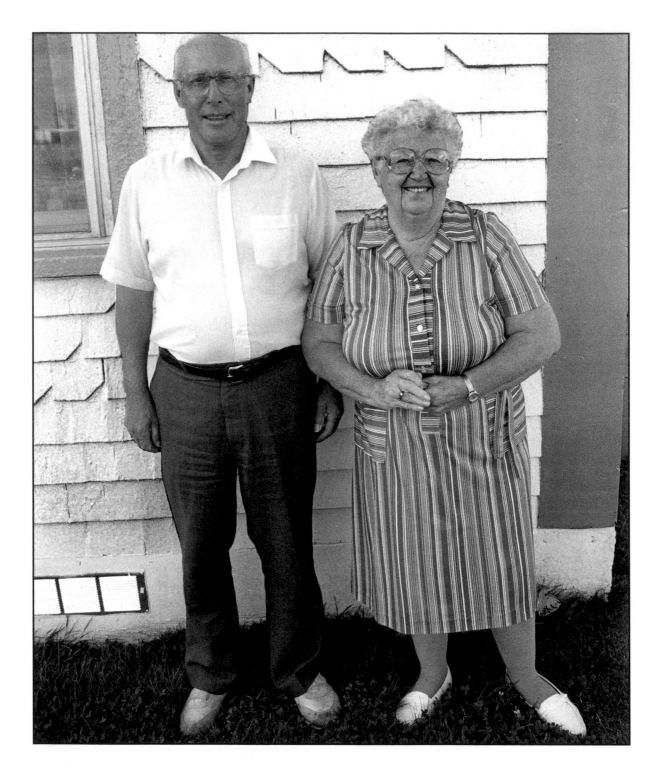

Vivian Cluett

Right now it's not so great here. People are really worried. It's the youngest it will be hardest on. For all of us older people, it's not so bad; the best of our days are gone. It's the younger generation, there are so many of them married with beautiful homes here; they shouldn't have to leave. What are they going to do? Where are they going to go?

I know it's not only Ramea and I know it's not only the fishery. It's just that everything is affected by the fishery. It's all layoffs. Layoffs. Layoffs. I get sick when I put on the TV. If everything does disappear, it will be a big change in people's lives. There will be a lot of sadness. People can't be happy if they can't live right. If you could work for ten months of the year, well you could survive, but if you're only going to get ten weeks of work to cover your stamps, I don't want to think about it. I don't want to think it will be bad enough for the fish plant here to never re-open, but if this is what it takes to improve the fishery, closing it down, I guess there is not much else you can do. People are having a lot of sleepless nights.

It's just like it was in the 1930s when things were really bad. The price of fish went down and money was real scarce. In Ramea, things were far from good. It stayed like that until Joey Smallwood came along, until Confederation. That is when people learned the difference. That is when people started to live. After Confederation, people had more to do with their health. Before that, we never had any doctors living here. The only things people ever used for anything wrong with them were Lionel's Liniment, a tonic called Beet Red Wine and kidney pills. I really think more people died young than should have just from not having enough food. When I was going to school, I had two good friends die. One had rickets, and the other had a heart attack at the age of eleven.

It wasn't until the 1940s that we got our first nurse. It was when tuberculosis was on the go. People were so scared. We had two hospital boats – *The Lady Anderson* and *The Christmas Seal*. They had everything aboard and they were a great blessing to those who needed them. Everyone would line up at the harbour and wait for their name to be called. That was how we got tested. TB was taking a lot of people, took them right around Newfoundland certainly and we were so afraid that we would get a bad report. Quite a few did get bad reports. If you had it, they would bring you out to the hospital in St. John's. This was long before they found the drugs. There was no cure, you just suffered through it. They were scary times.

My mother raised her family during those times. If one of us got sick, Mom took care of it. She had a midwife for all her babies; there were never any nurses for her. Midwives were more caring. They came when you asked them, stayed until the baby was born and came back every day for seven days to make sure everything was fine. I had a nurse for my last baby but that was only because I had to. I wouldn't change a midwife for a nurse if I had the choice.

My mother had eleven children and she breastfed every one of us. That's quite something considering there was only ever two years between us all. She always managed to keep us healthy, neatly dressed and fed better than most at that time.

My father died when he was fifty-four. Nobody knew how he died; I would say it was probably cancer but they didn't have a word for that then. After my father died, my mother had to raise her family on her own. She went to work at the fish plant and got what I suppose you would call a mother's allowance, twenty-eight dollars a week for all her children. After the boys were old enough to work at the plant themselves, she quit and they helped her to survive.

My father was a fisherman. He only got grade six but he was a smart man. He was a good hand-writer; he wrote lovely letters home when he was away, and he kept journals when he was on his boat. My father was only sixteen when he became captain. Being a captain made him a man.

In the summers he would leave on the tenth of June and not be back until the tenth of September. They spent every summer loading up their schooners with fish and when they brought it back, they distributed it to everyone by the quintal. Everyone fished then but they were poor times. There were tons of fish but no price to it. Now there is no fish but there is a good price. You can't win.

I remember when I was a kid going down to the salt water in my bare feet with a short broom to wash the fish and throw it on the flakes. We would be up at six every morning to spread the fish. We would turn it over at lunch time, and later in the afternoon we would go down to take it up. We kept doing that until it was dry enough to put in the shed. We'd keep it there then until it was time to weigh it and get it ready to sell.

There might be two or three women who would join together. They would use about six flakes. Others carried up loads of fish from dories to put out on the beaches across the harbour. They would wash it and spread it out and when it was dry, they would take it up and bring it back to the dories again.

It took two weeks to make a quintal of fish. If the weather was bad, it might take longer. When it was wet and foggy, we could never do anything with it, but if we managed three good days, we could save it. This is what we did when the men were out on the Banks fishing. They owned the fish but we got paid for drying it. We got three cents a quintal but any bit of money was better than not having any.

You might get paid more for working in the fish plant now but the cost of living is a lot higher. A pound of bologna was only twelve cents then. And you could get yeast for five cents a package. In it would be five little cakes, enough to make five loaves of bread with. We would raise our bread overnight and when we got up in the mornings, we put it in our pans to bake.

First thing in the morning, we lit the fire. It never stayed in overnight. We tried shovelling the ashes onto the wood to blanket it, to keep it going longer, but it still never lasted until morning. When I was a teenager, I was so scared to get out of bed in the wintertime because it was so cold.

We don't have winters like that anymore. We get lots of wind now, but it was a lot rougher then. We got so much frost. My father had to tack sail over the door inside to keep the draft out. We'd get up in the morning and the water bucket would be frozen solid. We'd have to take an axe to it to get a chunk of it out to boil for breakfast. I wouldn't want to do that over again and I sure wouldn't want our teenagers to have to live through it now.

We get enough weather now mind you; I don't care if I ever see another winter because they can still be hard. Every year we wait for summertime to come, for everything to clear. I expect this winter will be real hard, what with everything that is on the go here. It costs so much to heat houses

now. Take our house, for instance, it is one hundred and fifty years old and it's not well insulated. It costs three or four hundred dollars a month to heat it in the wintertime.

We might be all right, but for other families, it's a worry. They have no work and they are trying to raise their children, trying to send them to university. And then there are the ones who are already in university, they are coming out with degrees but there is still nothing for them to do. They are going in there spending all kinds of money, getting loans they may never be able to pay off, studying to get a chance at a job that may never exist for them.

I went to school until I was nine. What I picked up after that, I learned on my own. I was lucky. A lot of kids never got the chance to go to school. They had to get jobs when they were real young. Many went away. No one ever got degrees then.

I had to leave school to do chores around the house. I was the oldest so I had to do the most. Dad was away fishing all the time and my mother needed help. Sometimes my father was gone the whole year, even for Christmas. I remember one Christmas, he was supposed to arrive but he didn't get home until Old Christmas Day. Everyone was worried, they had left North Sydney two weeks before and it usually took twenty-four hours to come across. It was really stormy and they had no power except for their sail.

Mr. Penny, the owner of the schooner, would visit and try to ease Mom's worries. He told her that my father was probably docked somewhere to pass the storm. There were no telephones then so Dad could never have called if he had done that. We just had to wait it out.

The morning my father came in, I was the first one up. It was January 6, and I got up at four in the morning to look out. The windows were so frosted up, I had to blow my breath onto the pane to make a hole big enough to see the harbour. When I looked out that morning I saw lights. I immediately woke up my mother to tell her. At first she didn't believe me but when she got up to look for herself, she saw there was something out there so we woke everyone, lit the fire and waited.

You couldn't tell it was a schooner. It was so iced up it looked like an iceberg. When it got light enough outside, we could see all the men out on the deck in their rubber clothes. They had lost all their sails and were beating the ice off her before they came into shore. When they finally arrived, the customs officer went aboard to see what they had to pay duty on, and shortly after, Mr. Penny came up to tell us they were fine.

We had nothing for a cooked dinner so Mr. Penny sent us over a roast of pork; he raised pigs up on his land then. In the afternoon there was a dance in the lodge and we had a big celebration. We tried to make up for what we missed over Christmas. No one in Ramea had a good Christmas that year, we were all so worried. There were a lot of sleepless nights.

The trawlers are better equipped now. They have the power of their engines; they get back and forth faster. The schooners my father went out on only had their sails. Some of them were called ten-dory-bankers because they brought their dories with them. They'd anchor out on the Grand Banks, put their dories down with all the gear they needed, and they would fish two men to a dory. They don't do that anymore. It's been quite a change.

I wonder if they know in St. John's what it's all going to come to. Everything seems to be going downhill. I think if the fish plant doesn't re-open people won't take it sitting down. In the years gone by, we never used to fight because we didn't know the difference. Now, they have the TV and the radio; they are not going to take no for an answer.

If people don't fight, resettlement will probably happen again. I doubt if they will force them out, but people will have to move because there won't be any options left. I think it was the right thing to do at the time, to join Canada; we got a lot of things from it but what has it gotten us in the long run? Look where we are now. It's expensive to live, too expensive for most people. Things cost a lot of money when you don't have any work.

I can't see people in Ramea leaving though. Nobody wants to leave, not even the younger ones. It's hard to say what to do. My husband and I have lived here all our lives. We got married when we were eighteen. That's a long time ago. You learn a lot about each other when you are together in the same place for that long.

If we had to, we wouldn't know where to move. We had our wedding supper in the house we live in now and all five of our children were born here. They all grew up here and they all want to come back. I'm sure people wonder why we want to stay, but this is our home. The fishing life is our life. It's what we know. We were born to it. It's where we belong.

Vivian Cluett was born in 1924. She passed away in 2007 when she was eighty-three years old. Her husband Arthur has also passed away. Their son still lives in Ramea.

Afterword

BY SHEILAGH O'LEARY

As young townie women, we never would have had the opportunity to experience the people around this island like we did within the parameters of the Island Maid project.

Each of these women made huge contributions to their community. Aside from experiencing the women, however, it really was an incredible educational experience on a much larger scale. We were naïve young women going into it and there was a beauty in that naiveté. We set out, blindly driven by a passion, to know more about women's lives in rural Newfoundland. We weren't academics – our experience was emotionally driven, and if we didn't do it that way, then it likely would not have transpired.

Despite the fact that Rhonda and I had families in both central Newfoundland and on the west coast, we were still embedded in life in the capital. We had no concept of the acute differences from region to region. Through our travels, we had the opportunity to explore women and their role in their communities as well as to be exposed in a more

general sense to outport life. Much to our surprise, we encountered different women with completely different experiences – women like Sarah Benoit and her experience working in Boston. She was exposed to the world much like my own grandmother, Phyllis O'Leary, who was American born, but was an avid Newfoundland outdoorswoman. Then there were other women who lived very sheltered lives in the same community they were born into, never having travelled out of their community, yet at the same time, were very intelligent, with strong opinions and influence.

On a deeply personal level, this project had a profound and lasting effect on my life. It was the incredible strength and nature of these women who shaped my photography of people at its inception and fed my growing desire to contribute to my own community.

Acknowledgements

While many of the women in this publication have passed away since we first spoke over twenty years ago, they were all powerful and outspoken in their own way. Hopefully, with the help of this book, their voices will continue to be heard. To those who have gone and those who remain, it was an honour to have met you.

A very special thanks to my love, Frank Barry, for his patience and help. And to my father, Ron Pelley, for his life-long support and encouragement.

Thank you to all the people who have helped in some way past and present: Roberta Buchanan, Annamarie Beckel, Rhonda Molloy, Anna Kate MacDonald, Rebecca Rose, Sandra Pelley, Don Ellis, The Status of Women's Council, Anne-Louise Brookes, Liz Pickard, Manfred Buchheit, Flip Janes, The crowd in Jamestown, Barbara Neis, Mercedes Barry, Phil Dinn, Lois Brown, Jeff Cuff, Dana Warren, Vince O'Dea, Roberta Thomas, Louise Moyes and The Newfoundland and Labrador Women's Institutes. And to everyone who opened up their homes and hearts to us on our journey

This project was funded by:

The Canada Council for the Arts, Explorations Program

The Newfoundland and Labrador Arts Council

The St. John's City Arts Jury

Rhonda Pelley is a Newfoundland writer and artist whose work has been seen in galleries and publications locally and internationally. She lives in St. John's with her partner Frank Barry and her two cats Henry and Lucy.

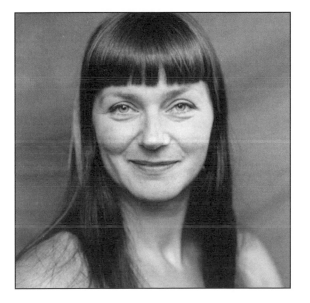

Sheilagh O'Leary is an award-winning art photographer, St. John's city councillor and mother of three. Her previous book, *Human Natured: Newfoundland Nudes*, spans almost two decades of her black-and-white nude photography, exploring intimacy between subjects and the Newfoundland landscape.

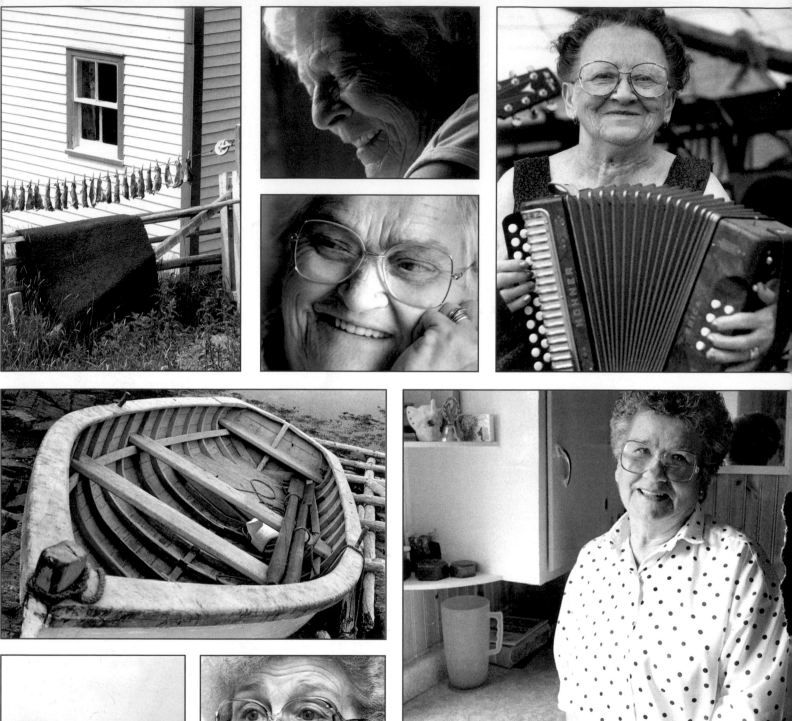